IMAGES
of America
LEWISVILLE

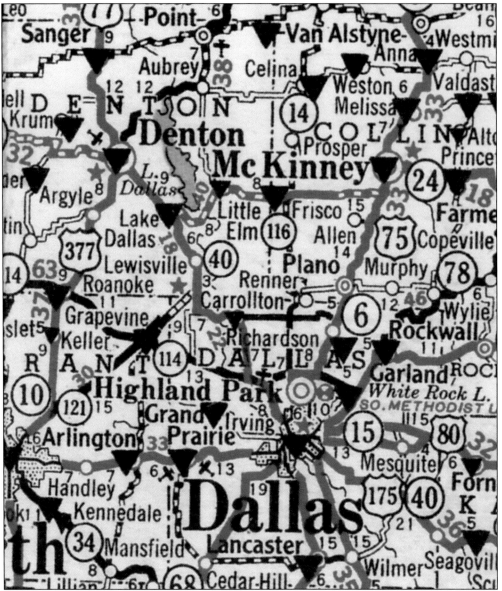

ON THE MAP. In this 1934 map, Lewisville was still a small village in southeastern Denton County. Within a span of 50 years, the city's population and boundaries greatly expanded, making Lewisville one of the largest cities in North Texas. (Courtesy Red River Historian.)

ON THE COVER: HEART OF LEWISVILLE. Though "City Garage" is stamped on the building, it had become the Lewisville Feed Mill by the time this picture was taken in 1962. The feed mill was the longest-running business in Lewisville and was often the center of community activity. Pictured from left to right are D.C. Degan, Harlee Hare, Joe Simpson, Tommy Perry, Lewis Champion, Fred Duwe, James Degan, Roland Mays, and Mecal Brown. (Courtesy James Polser.)

IMAGES
of America
LEWISVILLE

Robin Cole-Jett

Copyright © 2011 by Robin Cole-Jett
ISBN 978-0-7385-7993-1

Published by Arcadia Publishing
Charleston, South Carolina

Printed in the United States of America

Library of Congress Control Number: 2010940829

For all general information, please contact Arcadia Publishing:
Telephone 843-853-2070
Fax 843-853-0044
E-mail sales@arcadiapublishing.com
For customer service and orders:
Toll-Free 1-888-313-2665

Visit us on the Internet at www.arcadiapublishing.com

To my husband, Raymond, and my son, David, who are proud Lewisvillians, and to all those wonderful residents, librarians, and historians who made this book possible.

Contents

Acknowledgments		6
Introduction		7
1.	Farmers on the Prairie: Early Lewisville	9
2.	Farmers in the City: Growing Lewisville	49
3.	Fighting Farmers of Lewisville: Scholarly Lewisville	77
4.	Farmers on the Water: Lake Lewisville	97
5.	Farms No More: Modern Lewisville	113

Acknowledgments

So many people helped on this project that this book has become theirs as much as mine. I would like to thank the following people: Georgia Caraway, Kim Cupit, and Natasha Grau of the Denton County Museums and Roslyn Shelton of the Denton County Historical Commission, who gave me access to their extensive collections; James Polser and Virginia Polser of the Lewisville Feed Mill, who are true American originals; Don Epperson and Karen Holder from the Spencer family, who provided so much insight; Clyde Edmonds for his knowledge; James Crockett for his confidence; Dawn Cobb and Bryce Johnson for allowing access to old newspaper files; and to Pastor T.J. Denson, Shenee Denson, and Vernon Langston of Macedonia Ministries. Additionally, a big thanks goes to those tireless information professionals at the Denton Public Library, the Dallas Public Library, Lewisville Independent School District, and the City of Lewisville. Heartfelt thanks goes to Arcadia editors Winnie Rodgers and Kristie Kelly. If I omitted anyone, I sincerely apologize, as I am grateful to all those who opened their doors to me.

The images that are in this book and the memories that are recounted here come largely from oral histories compiled by the Lewisville Public Library; newspaper articles from the *Denton Record Chronicle* and the (now defunct) *Lewisville News*; city directories; Denton County histories by Bridges and Bates; and recollections from longtime residents.

INTRODUCTION

Today, the city of Lewisville is a sprawling suburb situated just north of Dallas and Fort Worth in southern Denton County. With its many shops, recreational opportunities, parks, and modern homes, the city offers varied and diverse lifestyles. Lewisville is more than just a feeder city to the giant metropolises, however. Just like its people and explosive growth, Lewisville's history stands out.

When New Spain (and later Mexico) ruled over Texas in the centuries before 1836, subgroups of the Wichita tribe claimed the area that is now home to Lewisville, as they had for thousands of years before. The area never enticed enough interest for Mexican pioneers, who thought it too remote and dangerous. After Texas independence, however, settlement patterns changed.

Americans, eager and willing to head west and eke out a living on the fertile prairie, invested in the Texas and Immigration Land Company. Led by William S. Peters, a British musician, these pioneers of "Peters's Colony" came in 1844 from England, Kentucky, Tennessee, Missouri, and Arkansas to establish the first settlement in what would become Denton County. John and James Holford, two of the original land grant holders, settled in what the surrounding farmers called Holford's Prairie. In 1853, Basdeal W. Lewis bought the farm on Holford's Prairie, named the new community after himself—Lewisville—and the city was born.

Originally, Lewisville began on a small hill about a mile northwest of where city hall sits today. The John B. Denton Masonic Lodge No. 201 built a two-story hall, which was shared by everyone in the community, including churches and schools. The Old Hall Cemetery is the only reminder today of where the original town once stood.

Lewisville's geography provided a near-perfect setting for large-scale agricultural activities. Once the grasslands were cleared, cotton became a staple crop. Stands of the famous Cross Timbers gave way to the plough. Predominantly nomadic, Native Americans used the territory only sporadically, and Sam Houston's treaty with North Texas tribes at nearby Grapevine Springs lessened the threat of attacks on settlers. Lewisville began to grow quickly; the first post office opened in 1853. Three men, Rawlins, Kealy, and Herod, founded the county's first gristmill in 1862, and five years later, Lewisville became the site of the first cotton gin in all of Denton County, built by T.M. Clayton and George Craft. Because of their need for running water, these industries moved closer to the Elm Fork of the Trinity River. Other businesses, eager to grow with the gins and mills, followed suit. The original town site at Old Hall was abandoned, and Lewisville grew in a new location that town boosters today refer to as "Old Town."

Lewisville opened two schools—one for whites and one for blacks—in 1877. The school district would eventually encompass several community schools, such as the Donald, Round Grove, Willow Springs, Midway, and Broomweed Schools. In an homage to its pioneer roots, Lewisville Independent School District, established in the 1940s, christened its sports team the "Fighting Farmers." Desegregation occurred within a year of the congressional orders in the early 1960s.

Transportation figured prominently in the progress of Lewisville. The town received Denton County's first railroad in 1878, when the Dallas and Wichita Railway, funded in part by Dallas

pioneer John Neely Bryan, terminated its tracks just south of Lewisville. In 1880, the Texas & Pacific Railroad extended the tracks into Denton; in 1881, the Missouri-Kansas-Texas Railroad acquired the right-of-way, thus linking Lewisville to wider markets. The interurban trains that connected Denton to Dallas stopped in Lewisville as well. While the rail stations proved to be the busiest places in town, their locations in a shallow valley close to the Trinity River made them prone to flooding. Businesses along Main Street thus centered on a gentle hill directly above the railroad line. The idyllic setting also brought a federal highway, US 77, in the 1920s. By the 1960s, Interstate 35 wound its way through the western side of town, opening up the city for more development. The establishment of Dallas–Fort Worth (DFW) International Airport in 1974 further enhanced the city's commerce and growth.

With its increasing population, Lewisville received an incorporation charter in 1925, converting the town into a city. Its industrious citizenry greatly assisted in building the prosperity of the town, and their influence still echoes throughout Lewisville's Old Town historic district. In 1886, J.W. Degan established a feed mill and livery station that lifetime Lewisville resident and Degan descendant James Polser still runs. In 1891, Overton Littleton Hamilton founded the *Lewisville Enterprise*, the town's first newspaper, and another one of its publishers, Jack Lewis, served as mayor in 1929. In 1927, J.L. Huffines opened his car dealership, showcasing flashy Chevrolets in a building that still bears his name on Main Street. One of the area's largest farms belonged to the Fox family, whose land would later be flooded by the building of Lake Lewisville in the 1950s.

Even with its can-do spirit, tragedy did not let Lewisville go unscathed. Downtown Lewisville suffered through three major fires in its history. The first occurred in 1895, when the north side of Main Street was destroyed. Thereafter, business owners created the Lewisville Water Company to guard against other fires, but tragedy struck again in 1912, when a man was killed by a fire that started inside the hotel on Main Street. In 1918, the north side of Main Street experienced yet another inferno. Other violent incidences left citizens reeling as well, such as two highly publicized bank robberies. Raymond Hamilton, once a member of the notorious Barrow Gang, held up the Lewisville National Bank in 1934. In 1946, Navy veteran S.A. Bruggemeyer robbed the Lewisville State Bank and was tackled by the high school football team during his escape attempt. The city's incorporation allowed for the hiring of police and firemen, something the city seemed to need after all these events.

The phenomenal growth of Lewisville from a small farming village to a major city underscores the fact that Lewisville's history is still being written. The city is growing geographically by welcoming commuter trains from Denton to Dallas and having annexed areas to the east, south, and west in the last decade of the 20th century. The city is growing culturally, too. An outdoor learning area for Lewisville students occupies a rugged and forested area just south of the lake, and the Elm Fork Park allows citizens to hike, canoe, and fish around the Trinity River. The city is also growing demographically, with a large immigrant population and a vibrant Hispanic business district. Then, the city is growing historically. The new city hall anchors the Old Town Historic District around Main Street, where a farmer's market, shops, restaurants, and a theater cater to both residents and visitors. Lastly, the city is growing economically. In 1981, Lewisville excitedly welcomed the Xerox Corporation, which made the city a major distribution center.

Lewisville, which today is home to more corporate workers than cotton farmers, has proved many times over that it is a historic place that boldly looks forward to the future.

One
FARMERS ON THE PRAIRIE
EARLY LEWISVILLE

Lewisville's origination story is not so different from the many other farming communities that developed out of the Peters Colony Land Grant Company. The company, chartered by the Republic of Texas in the 1840s to quickly populate the North Texas region, offered male heads of households 640-acre tracts of land and single men and women half that. All of the settlers had the following two common goals: to create a sustainable (and hopefully profitable) farm as quickly as possible and to pay off the mortgage on the land soon thereafter.

Early residents did not have much trouble with either goal. The land surrounding the Elm Fork of the Trinity River proved very fertile. In fact, soil geology of Denton County has confirmed that the eastern portion of the county is most conducive to farming. In contrast, the western areas of Denton County proved better suited for cattle grazing.

While most farms produced a variety of food and animals, cotton became the staple commercial crop. Planting and harvesting cotton is a very labor-intensive enterprise, and those who could afford to engage in this commerce did so by using slaves. Two of the main slave-owning families in Lewisville were the Foxes and the Hembrys, each owning eight slaves. After the Civil War finally freed men and women from bondage, many longtime black Lewisville residents established their own neighborhood in the southeastern outskirts of Lewisville.

Within 20 years of establishing permanent settlements, Lewisville could boast a gristmill and a cotton gin, the first of their kind in the county. The town also had three saloons, four churches, and a school located where the town's original cemetery sits. The city was well on its way to becoming a center for farming and commerce.

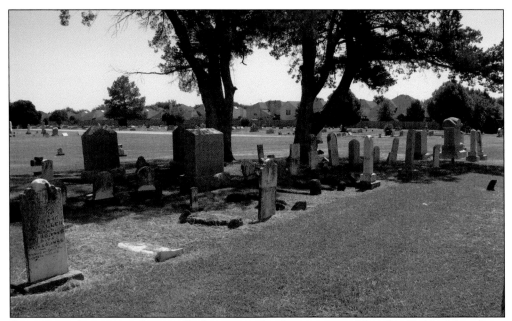

OLD HALL CEMETERY. Lewisville began on land once owned by the Holford brothers, original homesteaders of the Peters Colony Land Grant Company. In 1859, the Masonic Lodge built a two-story hall that was used by the John B. Denton Lodge, various churches, and the community school. The founding location of Lewisville is now the city's cemetery, located on McGee Street. (Author's.)

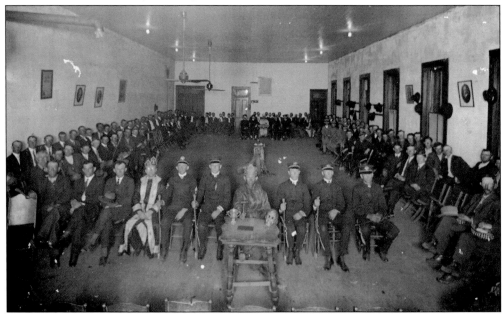

MASONIC BENEVOLENCE. The Freemasons have been great community assets for many Texas cities, and Lewisville's chapter proves that point. The John B. Denton Lodge No. 201 built Lewisville's first public building in 1859. The second Masonic hall occupied the second floor of a commercial building on Main Street. Today, the Masonic lodge meets in a more modern facility at the corner of Manco and Main Streets. (Courtesy James Polser.)

CURTIS FARM. Bob and Mattie Curtis, along with their six children, farmed the prairie in the southeastern corner of Denton County in the latter half the 19th century. Lewisville developed from the farms that clustered around the office of the Peters Land Grant Company, which sat inside a cabin near the Denton County settlement of Hebron. (Courtesy James Polser.)

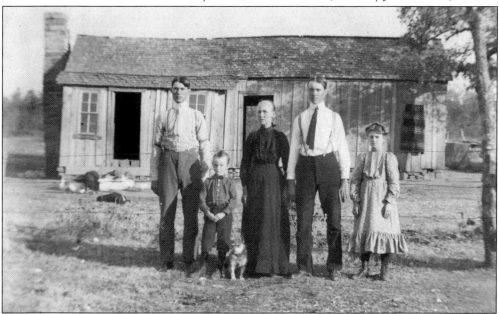

RITTER FARM. William R. Curtis married Elgerett Ritter, daughter of original Peters Colony land grant holder William Ritter. The couple and their children farmed the Ritter homestead, which sat east of downtown Lewisville. An oxbow lake on their land provided recreational opportunities for generations of Lewisville residents. Notice the dogtrot architecture of their home, a typical style of early Texas pioneers. (Courtesy James Polser.)

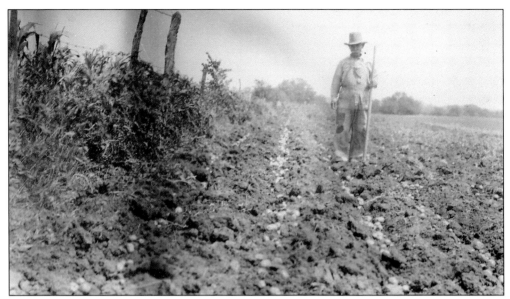

GERMAN FARMERS. In the 1870s, German immigrants moved to the Round Grove community, just south of Lewisville. There, they founded a church and a school and often conducted business with Lewisville merchants. William Barfknecht, pictured in his potato field, was a descendant of one of these immigrants. This photograph was taken by H.F. Browder, a Denton County extension agent, in 1920. (Courtesy Denton County Museums.)

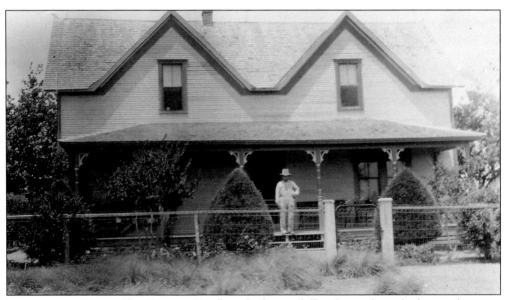

BARFKNECHT FARM. The German Barfknecht home differed significantly from other area farmhouses. A tidy, fenced yard with fruit trees and ornamental shrubbery separated the house from the fields. H.F. Browder, the Denton County extension agent, took this photograph in 1920. (Courtesy Denton County Museums.)

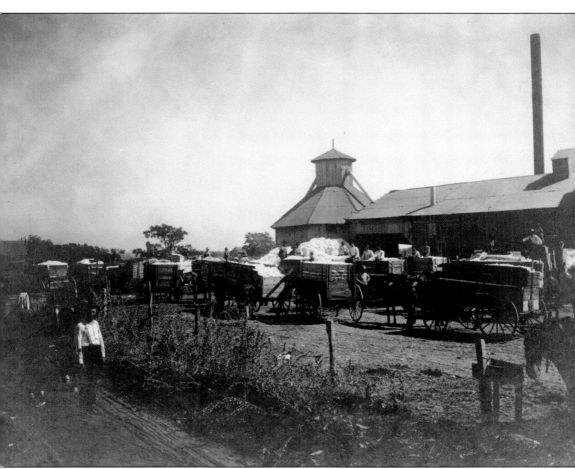

COTTON BUSINESS. Taking full advantage of the fertile soil in southeastern Denton County, Lewisville farmers grew lots of cotton. Due to this brisk business, T.M. Clayton and George Craft opened the county's first cotton gin in Lewisville in 1867. They located the gin about a mile away from the original town site to be close to creeks and near the Elm Fork of the Trinity River. Within the next four decades, the Degans and the Cunninghams would also own cotton gins in the area, and residents would leave the old settlement at Holford's Prairie to live, work, and conduct business in what became the new town of Lewisville. (Courtesy Spencer family.)

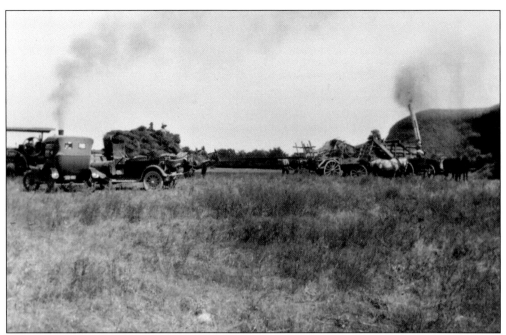

OF MULES AND MACHINES. In this 1920s photograph of a farm outside of Lewisville, a steam-driven tractor and a mechanized baler work alongside mules and carts. Farms that ran entirely on machines were not a common sight until well into the last half of the 20th century. (Courtesy James Polser.)

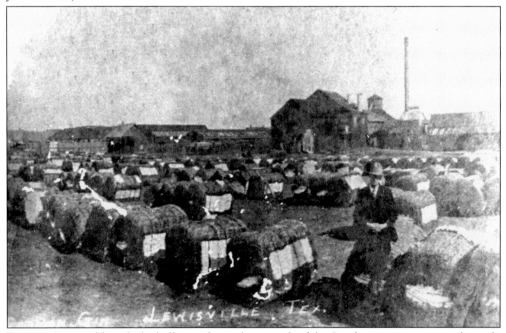

BUMPER CROP. Although the boll weevil wiped out much of the Southern cotton crop in the early 1920s, Lewisville was able to diversify its economy, which forestalled a major crisis. In addition to cotton, farmers grew peanuts. The Degan cotton gin, depicted here, was located on today's Mill Street; the Cunningham cotton gin sat near the train depot. (Courtesy James Polser.)

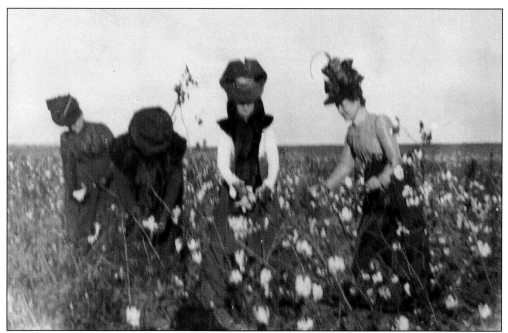

TALL COTTON. Picking cotton was heavy work. Before the Civil War, a handful of Lewisville farms practiced slavery. Afterwards, sharecroppers, tenant farmers, and seasonal workers mined the bolls. Women also picked cotton, though unlike in this photograph, never in their finest clothes. (Courtesy James Polser.)

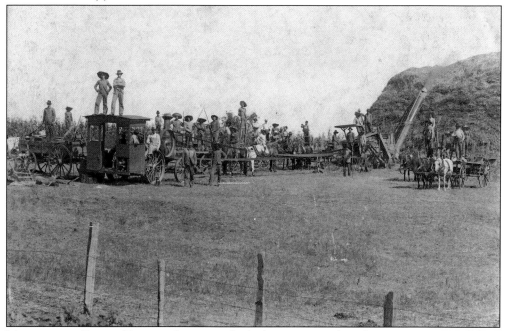

MECHANIZING LABOR. Farm machinery made the harvest easier but also more expensive. Often, a farmer bought the equipment to rent it out to other farmers, or farmers hired a contractor to get the work done. In this 1900 photograph, Bob Evritt and his crew work the thresher on Frank Comb's farm in Lewisville. (Courtesy James Polser.)

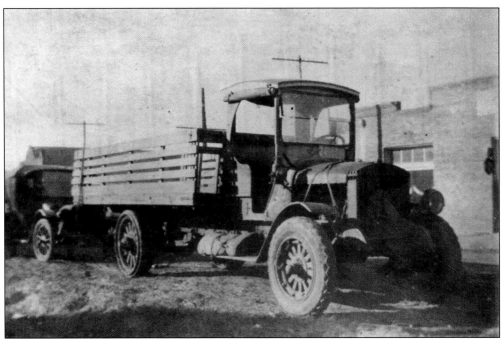

TRUCK FARMING. To get crops to market, early Lewisville farmers relied on carts driven by mules. Crops would then be loaded onto trains or trucks from the mills, gins, and silos. Bob Greer bought the first freight truck in Lewisville to accommodate the crops. (Courtesy James Polser.)

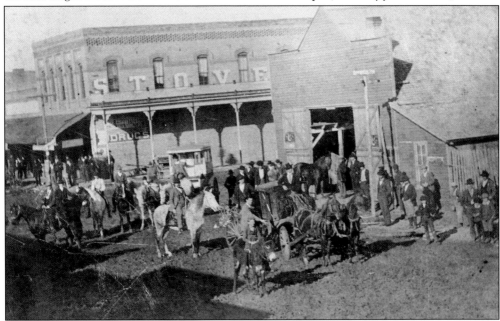

LEWISVILLE'S FRONT SIDE. J.W. Degan's Livery Stable, opened in 1886, stood at the northeastern corner of Main and Mill Streets. In 1932, James Degan tore down the livery stable to make way for his next venture, a Chevrolet automobile dealership. The *Lewisville Enterprise* lamented that "like the horse . . . [it] has to go to make way for the modern means of transportation, the automobile." (Courtesy James Polser.)

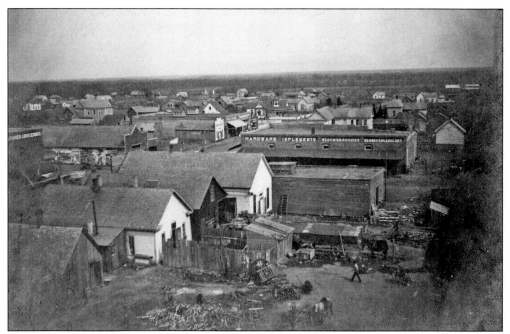

LEWISVILLE'S BACKSIDE. Looking northeast onto the intersection of Main and Mill Streets, Lewisville's growth is readily apparent. Jacobsen's hardware store can be seen in the middle of the photograph, and James Degan's livery stable, with the barn-style facade, sits directly across from it. (Courtesy James Polser.)

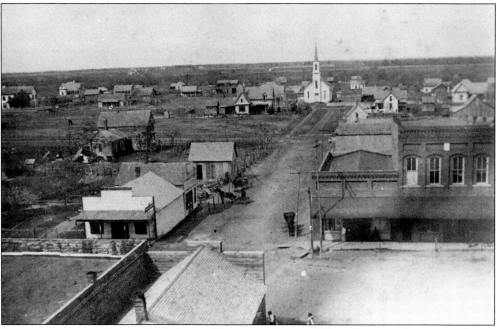

LEWISVILLE TO THE NORTH. Early Lewisville clustered around Main Street, with most residences to the north of the commercial block. Looking north up Poydras Street, one could walk to the Methodist church. Today, northern Poydras Street ends at the Lewisville City Hall. (Courtesy James Polser.)

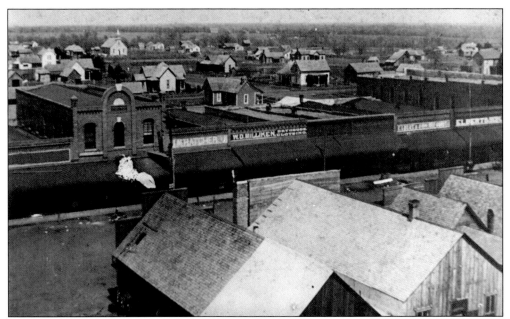

PROMINENT SIGN. The north side of Main Street held Milliken Dry Goods Store, one of many grocery stores in Lewisville. In periods throughout his life, W.D. Milliken served as the president of Lewisville National Bank, was on the school board, and held the grand master position at the local Masonic lodge. The Church of Christ Building is clearly visible in the background. (Courtesy James Polser.)

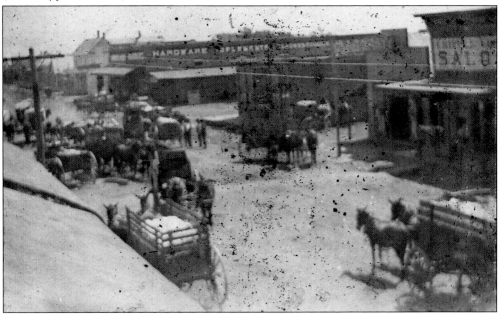

LEWISVILLE TO THE WEST. Harvest time brought everyone into town, as did Saturday nights. Longtime residents remembered that stores stayed open until midnight on Saturdays, when everyone came into town to see and be seen, visit and be visited. Lewisville merchants, including saloons, gladly welcomed the business. Party people could find other saloons south of Lewisville along the Trinity River bottoms. (Courtesy James Polser.)

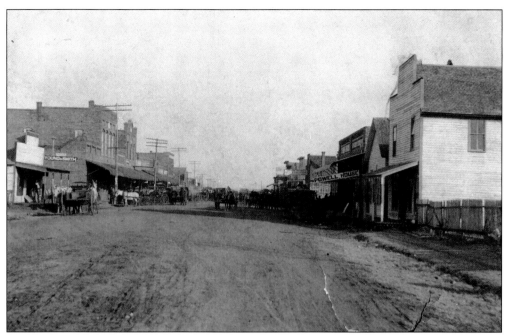

LEWISVILLE TO THE EAST. Looking east down a muddy Main Street, this photograph depicts a typical downtown scene in early-20th-century Lewisville. The Powell House, which rented rooms, is next to the Cobb Brothers Store, which stands next to a blacksmith shop. Across the street from the Powell House is the Young and Smith Drugstore. (Courtesy James Polser.)

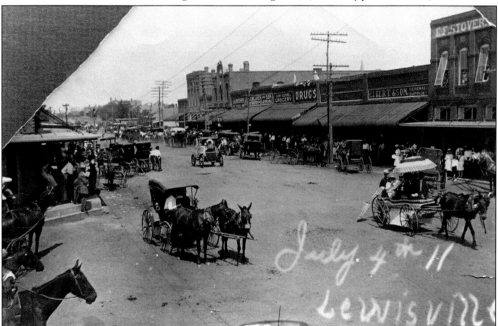

PROUD CITY. The Independence Day Parade of 1911 brought the whole community out to celebrate. Other celebrations were not that well attended; longtime Lewisville resident Ceora Hendrix related that after the Civil War, many Confederate veterans refused to acknowledge the Fourth of July. (Courtesy James Polser.)

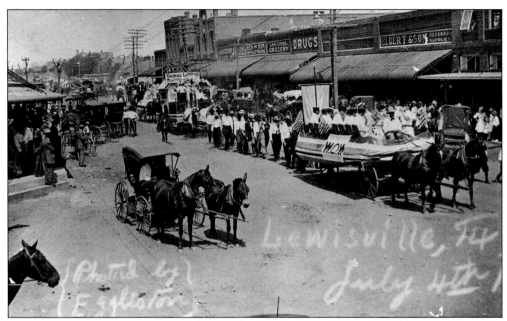

WOW Float. The Woodmen of the World, who sponsored the largest float for the parade on the Fourth of July in 1911, met in the second story of the W.W. Smith Grocery at the southwest corner of Main and Poydras Streets. Lewisville residents Grady Aaron and James Crawford recalled that the Smith Grocery served as a hangout for old-timers, who played dominoes around a wood-fired stove inside the store. (Courtesy James Polser.)

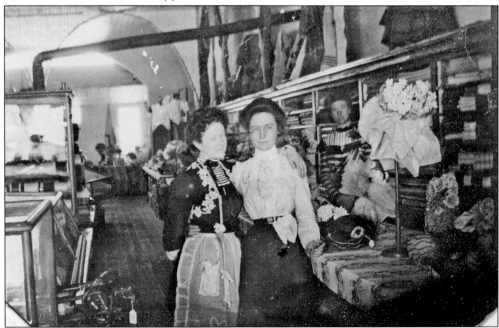

Shopping Opportunities. This photograph from 1901 depicts the interior of the Thomas, Fagg & Thomas Store, which sold "exclusive dry goods." At the turn of the 20th century, customers could choose from a wide variety of merchants in downtown Lewisville, including W.W. Sherrill, G.W. Elbert & Son, Phil R. Hyder, W.D. Milliken, and James Hayes. (Courtesy James Polser.)

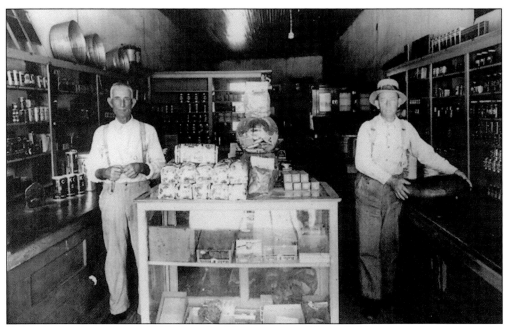

LOARD'S GROCERY STORE. W.C. Loard sold groceries and household items in his shop on the south side of Main Street in the early 20th century. (Courtesy James Polser.)

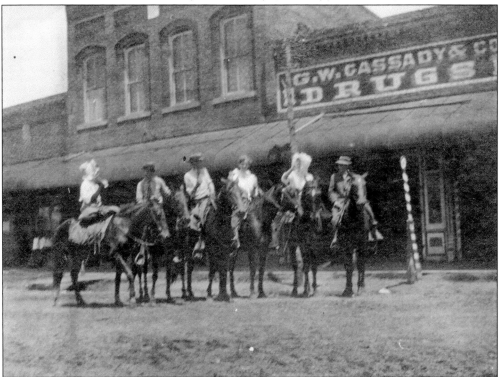

CASSADY DRUGSTORE. Men and women from the Spencer family enjoy a horseback ride in front of the G.W. Cassady & Co. Drugstore in downtown Lewisville. The two-story brick facade behind them housed Lewisville's Masonic lodge. (Courtesy Spencer family.)

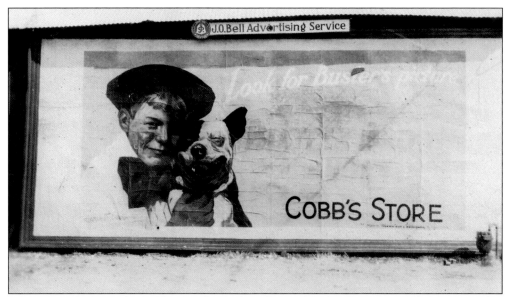

COBB'S DRY GOODS. The Cobb Store, located on the south side of Main Street between Poydras and Charles Streets, originally occupied a wooden structure dating to 1874. In 1902, the Cobb brothers erected a new brick storefront in which they sold groceries, fine china, and glassware. They also maintained a brick yard in the back. Elmer E. Williams from Dallas bought the Cobb Store in 1955. (Courtesy James Polser.)

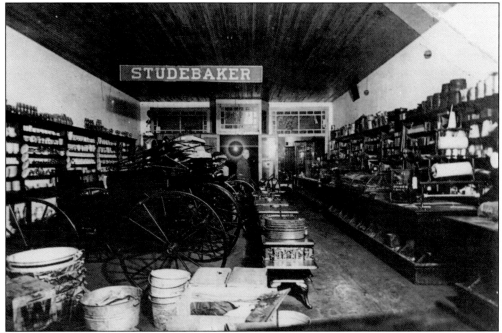

CONVENIENCE STORE. The Jacobsen and Son Hardware Store sold more than just hammers and nails—they also sold buggies made by the Studebaker Company. Next door to the hardware store stood Fred Duwe's Mule Barn. This made it easy for a customer to buy a horse from Fred Duwe and a carriage from Christian Jacobsen, then store his purchases at J.W. Degan's livery stable across the street. (Courtesy James Polser.)

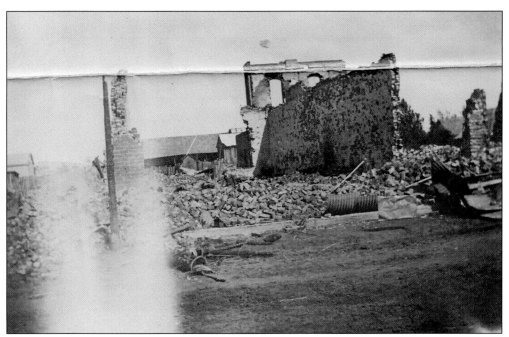

FIRE OF 1914. Lewisville, like most other towns throughout Texas, suffered a number of fires that devastated its commercial district. The fire in 1914 destroyed J.M. Hendrix's Furniture Store and Undertaking Parlor (furniture stores often performed death services because they had the equipment to move large objects, such as caskets). (Courtesy James Polser.)

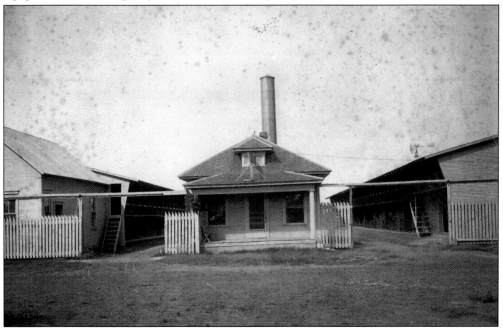

SHERRILL WATER TOWER. Behind the lumber yard on Mill Street stood the town's water tower, which William Sherrill erected with a community grant. After a fire burned the business district in 1895, the city wanted to ensure that it had access to a water reservoir. (Courtesy Henrietta Cobb Sherrill and James Polser.)

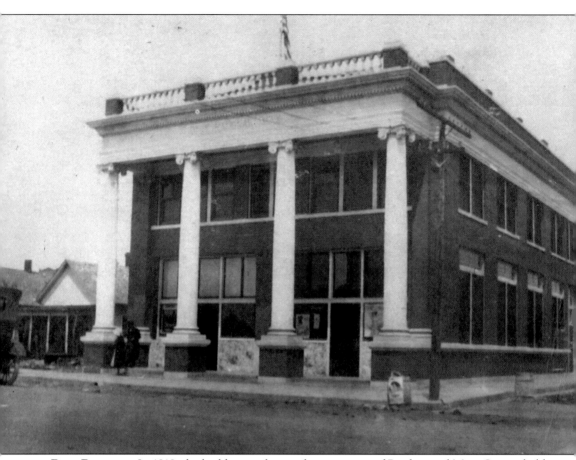

BUSY BUILDING. In 1918, the building at the northwest corner of Poydras and Main Streets held many tenants. The First National Bank and the post office occupied the first floor, with the telephone office in the second story. Bud Kealy served as a longtime postmaster, and Maude Higgins was Lewisville's first telephone operator. (Courtesy James Polser.)

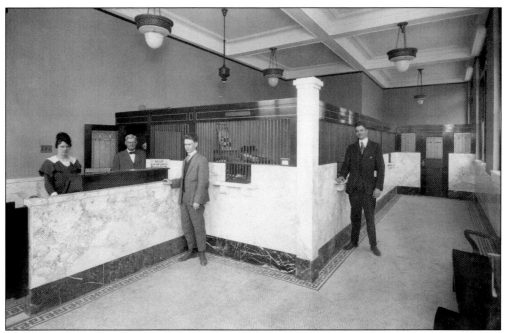

FANCY LOBBY. The marble interior of the First National Bank attested to the good financial times enjoyed by many Lewisville residents in the 1920s. The market collapse of 1929 did not affect the city very much, as capital was diversified in farming, real estate, and other holdings. Benjamin Spencer founded the bank at the turn of the 20th century. (Courtesy Spencer family.)

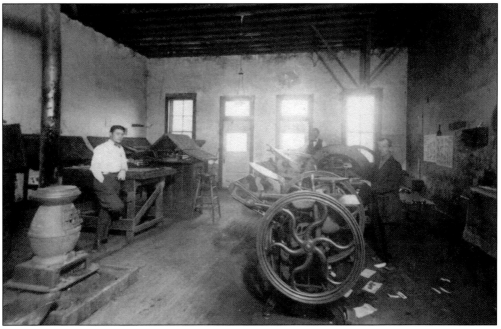

IN THE NEWS. Behind the First National Bank Building on Main Street stood the presses of the *Lewisville Enterprise*, the town's first newspaper, founded by Overton Littleton Hamilton. One of its longtime publishers was Jack Lewis, who hailed from England and later served as mayor. The *Enterprise* became the *Lewisville Leader*. (Courtesy James Polser.)

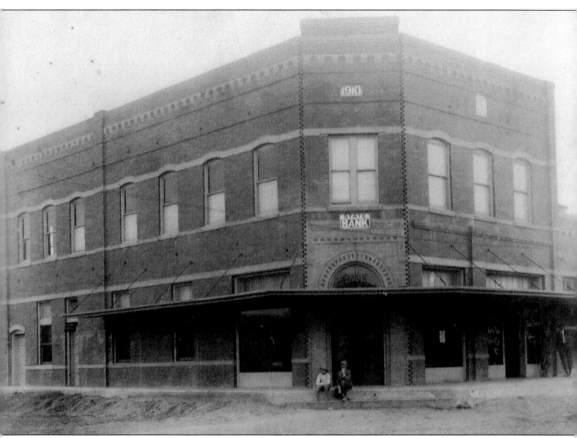

GINNING BANK. The First State Bank, founded by J.W. Degan, stood on the southwestern corner of Main and Mill Streets, adjacent to the cotton gin. Farmers processed their cotton at the gin and received script as payment, which they cashed in at the bank. The bank deducted from the script any rents and fees due. Script payments were IOUs that businesses issued in lieu of cash. This forced employees to purchase items and bank only at institutions that accepted the scripts. (Courtesy James Polser.)

POST-ELECTION "MOURNING." Lewisville residents tended to be progressive and civic-minded, but they enjoyed a good joke, too. After election day in the 1920s, voters "buried" the losing candidates with mock tombstones on Main Street to commemorate good, but failed, ambitions. The dirt street made this a relatively easy task to accomplish. (Courtesy James Polser.)

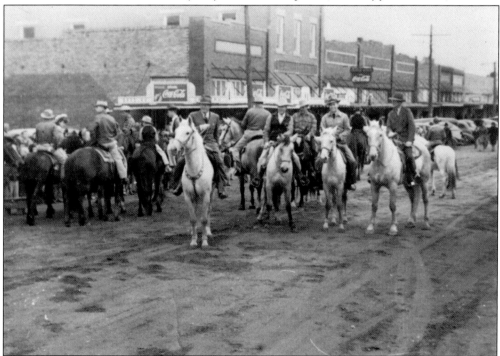

VISITING DIGNITARIES. In 1938, Texas lieutenant governor Walter Woodul visited Lewisville. J.L. Huffines, Buddy Purnell, Mike Wolters, Aubrey Polser, and George Reed rode into town on horseback to greet him. Woodul, a Democrat, would have been welcomed in Lewisville, where Roosevelt's New Deal policies were looked upon favorably. (Courtesy James Polser.)

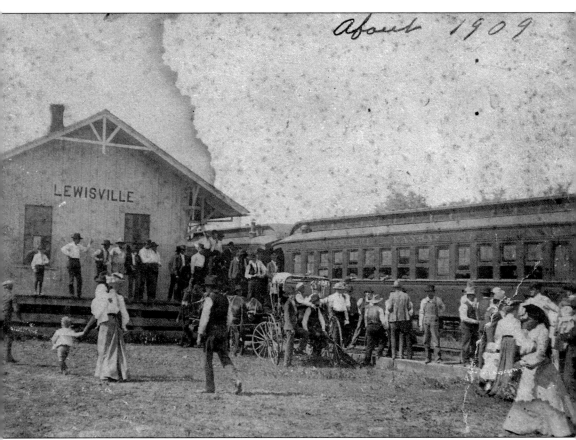

FOUNDING RAIL. Lewisville became the first Denton County town to welcome a railroad when the Dallas and Wichita Railway reached its southern boundary in the late 1870s. After the Missouri-Kansas-Texas Railroad (MKT) extended the rail through Lewisville and into Denton in 1881, Lewisville's growth was assured. By the 1920s, long-distance trains shared the track with the Dallas-Denton Interurban. The MKT depot, which was painted a "greenish yellow" color, served passengers on one end and freight loads on the other. The depot was not segregated by race and stood at the southeastern corner of Main and Railroad Streets. It became the city's main attraction whenever the "Katy Flyer" (pictured) came through. (Courtesy James Polser.)

CONNECTIVITY. In September 1924, the interurban streetcar from the Dallas Traction Company began daily service from Dallas to Denton, with an hourly stop at the train station in Lewisville. The company touted its route through a promotional brochure called *Neighbors*, in which Lewisville's architecture was prominently featured. Pictured are, from top to bottom, First State Bank at the corner of Main and Mill Streets, the Griffen house on Herod Street, Lewisville School at the corner of College and Cowan Streets, Christian Jacobsen's house on Herod Street, and the First National Bank on the north side of Main Street. (Courtesy of Denton Public Libraries.)

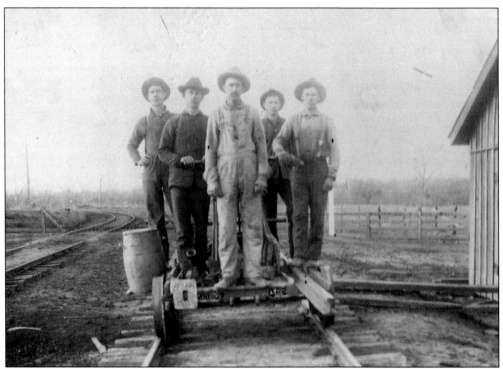

WORKIN' ON THE RAILROAD. The coming of the railroad spurred development throughout North Texas. In Lewisville, the train's arrival signaled new business—like hotels and restaurants—and new jobs, too. In this photograph, a work crew on a handcart maintains tracks in Lewisville. (Courtesy James Polser.)

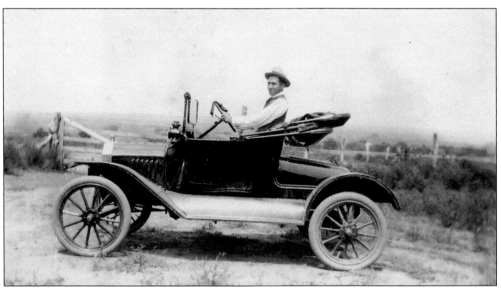

FIRST CAR. James Franklin Degan owned a Chevrolet dealership in Lewisville where local doctor D.F. Kirkpatrick bought the first car in town. A Ford dealership was located on east Main Street. (Courtesy James Polser.)

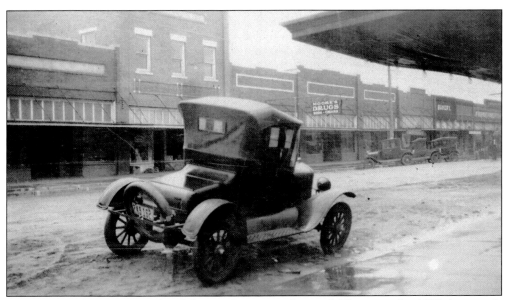

MUDDY MAIN STREET. Rainy days left Main Street mired in mud. The car in this 1927 photograph faces east on Main Street, where Moore's Drugstore, a bakery, and a furniture store can be discerned through the mist. (Courtesy James Polser.)

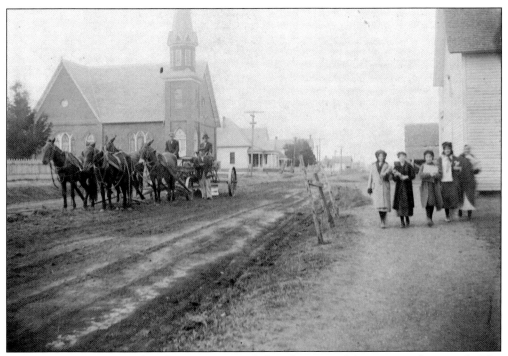

STREET IMPROVEMENTS. Church Street gets graded in this turn-of-the-century photograph. The First Baptist Church is in the background. The mule teams probably belonged to a local contractor. The schoolgirls walking past the contractor must have been happy to see improvements, as the streets became muddy and impassable after a rain and were choked with dust during dry times. (Courtesy James Polser.)

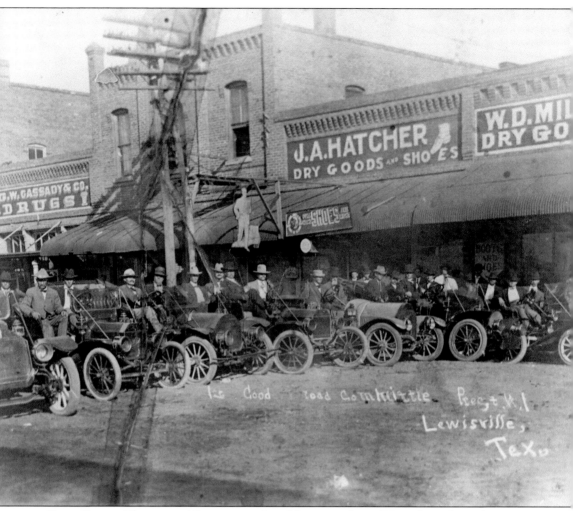

GOOD ROADS. The automobile age necessitated better road conditions throughout the country. During the Progressive Era, automobile owners formed clubs to lobby the state and federal government for improved streets. The Good Roads Committee of Lewisville also traveled around the area as "trade ambassadors" to promote local businesses. Chances are that the names on the stores in this photograph belong to many of the owners of these automobiles. (Courtesy James Polser.)

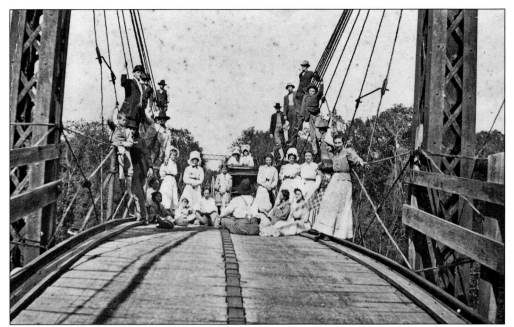

BRIDGING THE TRINITY. Lewisville residents who wanted to traverse creeks and rivers would know of a shallow water crossing, pay to use a ferry boat, or cross a bridge. The bridge depicted in this turn-of-the-century photograph linked the communities of Little Elm and Lewisville together over the Big Elm Fork of the Trinity River. This bridge was dismantled when Lake Lewisville was built. (Courtesy Denton Public Library.)

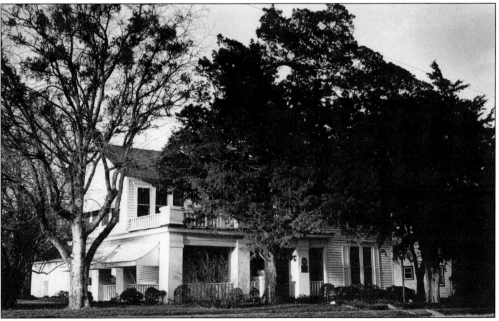

MILLIKEN HOUSE. The merchant Milliken family owned this house on Church Street, where many prominent families of Lewisville lived. Church Street was an apt name for this road, as the Baptist, Methodist, and Presbyterian churches could be found here. Sadly, all of Lewisville's early churches were torn down or otherwise destroyed. (Courtesy Denton County Museums.)

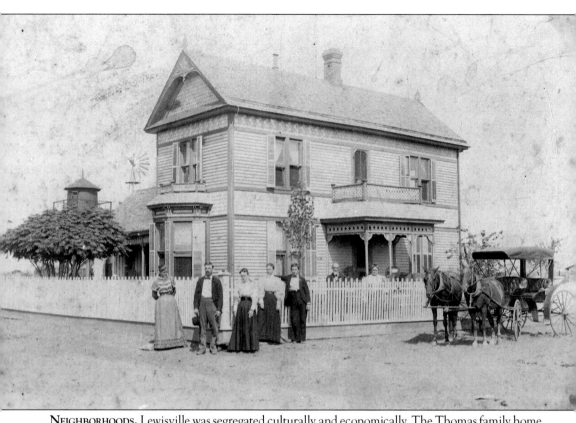

NEIGHBORHOODS. Lewisville was segregated culturally and economically. The Thomas family home, depicted here, sat at the corner of College and Herod Streets on "Sweet Milk Hill," the northern part of town, where prominent citizens lived. Down the hill by the train station lay "Buttermilk Flats," with working-class homes. Southeast of town along Hembry Street was an unincorporated, predominantly African American neighborhood. (Courtesy James Polser.)

Distinguished Gentleman. Martin Fagg served as the first mayor after Lewisville was incorporated in 1925. A residential road north of College Street in Old Town Lewisville bears his name. (Courtesy James Polser.)

Distinguished Lady. Lillie Fagg was the wife of Martin Fagg and proprietor of the Thomas, Fagg & Thomas Dry Goods Store, where she sometimes served customers behind the counter. (Courtesy James Polser.)

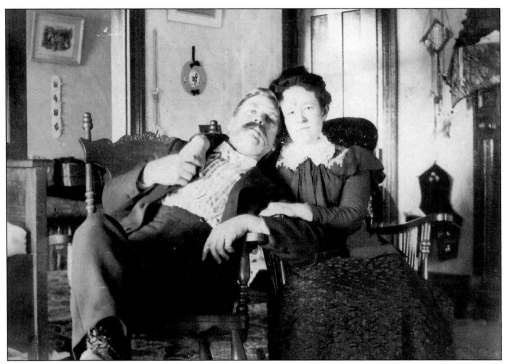

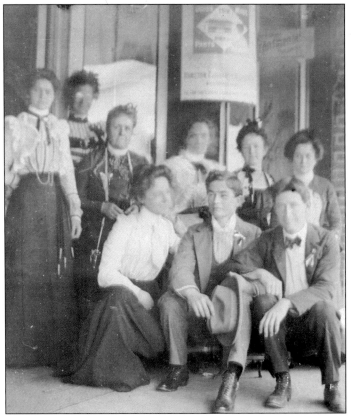

ENJOYING TIME TOGETHER. At the turn of the century, it was quite unusual for people to show much familiarity with each other in photographs, even if they were husband and wife. Martin and Lillie Fagg, however, seem to defy convention in this 1909 photograph of them relaxing in their Lewisville home. Their home still sits at the corner of West Richland Street and Lynn Avenue. (Courtesy James Polser)

STORE FAMILY. The Fagg family owned a dry goods store in downtown Lewisville. In this 1900 photograph, family members pose with employees outside of the store. (Courtesy James Polser)

Mr. Spencer. Benjamin Lafayette "Fate" Spencer, a native Tennessean, came to Lewisville in 1899 and opened the First National Bank, where he served as president until 1934. (Courtesy Spencer family.)

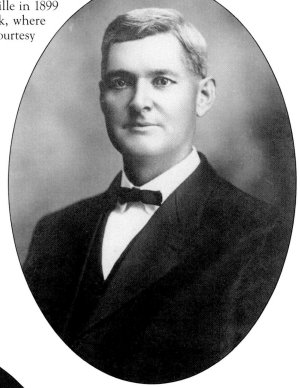

Mrs. Spencer. Annie Fowler from St. Louis, Missouri, married Benjamin Lafayette Spencer in 1883. They had one daughter, Helen. After moving to Lewisville in 1899, the Spencers built a large Victorian home on the western edge of town that became the focus of community events. (Courtesy Spencer family.)

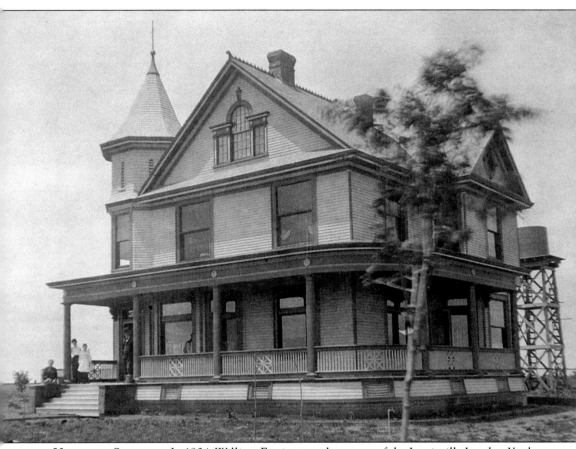

Victorian Splendor. In 1904, William Ferrington, the owner of the Lewisville Lumber Yard on Mill Street, designed and built the Spencers' house on Main Street at a cost of $5,000. Painted in a cheery yellow with intricate woodwork throughout the interior, the Spencer home was a longtime symbol for Lewisville until it was bought and moved to anchor a new housing development in Collin County in the 1990s. (Courtesy Spencer family.)

KING CORN. The Spencers were not only bankers but farmers as well. Here, Annie Spencer and her daughter, Helen, stand amidst a bumper crop of corn. Notice the water tower behind their home—it served as water supply and fire prevention for the Spencer family. Years later, an episode of the TV series *Route 66* featured downtown Lewisville and the Spencer home. (Courtesy Spencer family.)

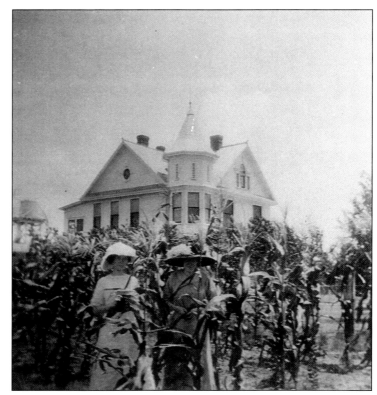

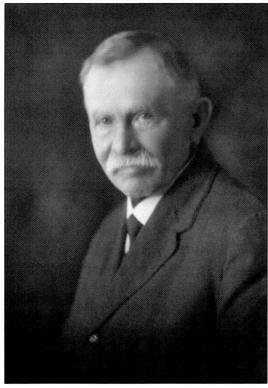

MR. JACOBSEN SR. Christian Michael Jacobsen owned and operated hardware stores in Lewisville and Denton at the turn of the century. A Danish immigrant, he married Lavina Stewart from Tennessee before moving to Lewisville. His son Peter married Helen Spencer. (Courtesy Spencer family.)

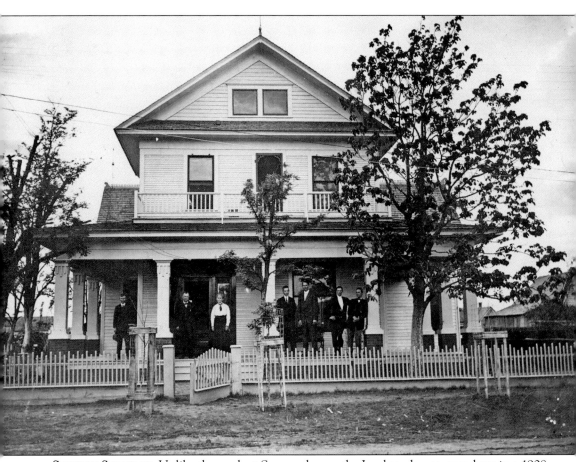

SENSIBLE SPLENDOR. Unlike the opulent Spencer home, the Jacobsen house, seen here in a 1908 photograph, could be considered relatively simple. The interior, however, was as stately as any home of the city's leading families. The house sat on North Herod Street. (Courtesy Spencer family.)

Mr. Jacobsen Jr. Peter Lausten Jacobsen married Helen Spencer in 1915. He and Helen lived in the Spencer home after they married and together ran the Jacobsen Hardware stores. (Courtesy Spencer family.)

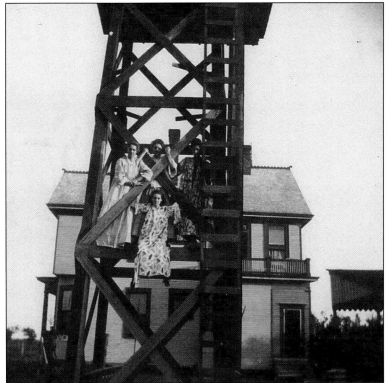

Helen Spencer Jacobsen. In 1912, Helen Spencer (standing behind the X made by the two-by-fours) and her friends climbed the Spencer water tower for this fun picture. Helen married Peter Lausten Jacobsen in 1915. The wedding was held at the First Baptist Church, followed by a reception at the Spencer house. (Courtesy Spencer family.)

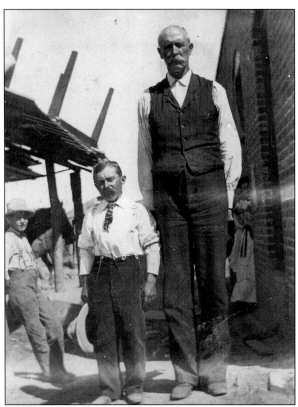

Mr. Young. Tom Young, who owned a grocery store on Poydras Street at the turn of the 20th century, was also the tallest man in town. He stood six feet, ten inches tall. (Courtesy James Polser.)

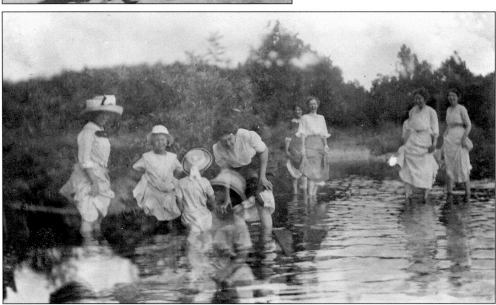

Refreshing Waters. With long summers and mild winters, Lewisville residents enjoyed their leisure time immensely. Ritter Lake, an oxbow lake formed by the Elm Fork of the Trinity River, served for decades as a recreational swimming hole and fishing pond. Named after William Ritter, the lake's original homesteader, Ritter Lake and its surrounding community were lost when Lake Lewisville was built. (Courtesy James Polser.)

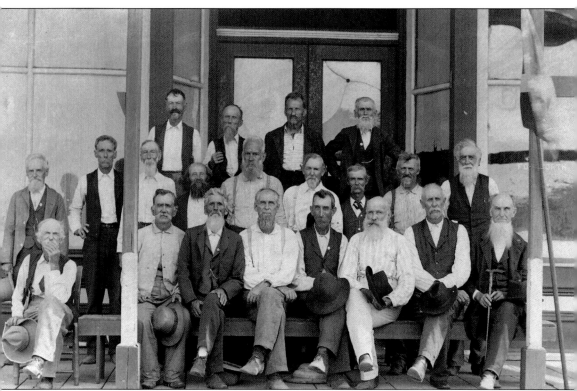

PINE KNOT CLUB. In 1900, a men's group known as the Pine Knot Club sat for a portrait in front of Young's Drugstore in Lewisville. Featured in no particular order are Bill Smith, Mr. Harwell, Mr. Lord, John Fox, Warren Durbin, Mr. Dorsey, Milt Claytor, Mr. Payne, Mr. McAnally, "Squire" Terry, John Shipp, Cush Williams, George Mayfield, Bill Crawford, and Mr. Clayborne. From left to right in front on the right side are Capt. Sam Lusk, Tom Young, and "Grandpa" Carlisle. (Courtesy Denton Public Library.)

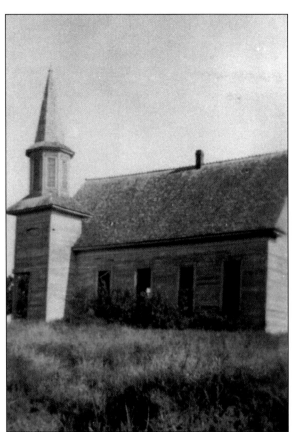

Rural Church. Built in the 1880s, this church served Presbyterian, Baptist, and Methodist congregations in the Bethel community, just northwest of Lewisville near today's Farm to Market Road 407 and Highland Village Road. The congregation of Grace Presbyterian moved the church to the northeast corner of Kirkpatrick and Morriss Roads, where it now can be reserved for weddings. (Courtesy Denton County Museums, Denton Record Chronicle Collection.)

Presbyterian Church. In 1879, Presbyterians who had been worshipping at the Old Hall Building constructed their very own church at the corner of Charles and Church Streets in downtown Lewisville. After erecting two more modern buildings on the site, the congregation left downtown to expand their church at the corner of Fox Avenue and Edmonds Lane. (Courtesy Denton County Museums, Denton Record Chronicle Collection.)

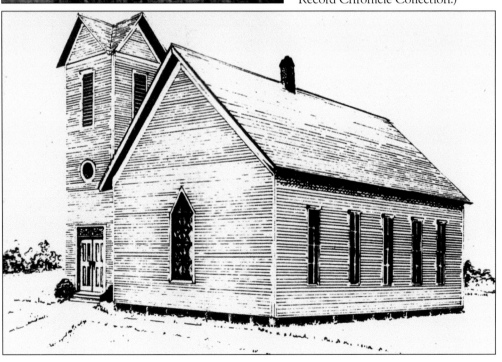

CHURCH OF CHRIST. At the beginning of the 20th century, Lewisville had six churches scattered throughout town. The Church of Christ was one of these churches. Occupying a small white clapboard building in the northeast section of town, the congregation moved west across Interstate 35 when it outgrew its old buildings. (Courtesy Denton County Museums, Denton Record Chronicle Collection.)

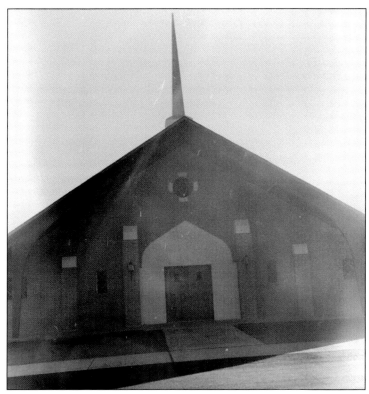

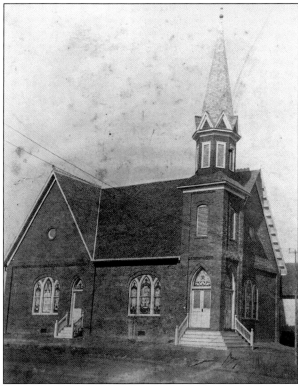

NORTH BAPTISTS. The First Baptist Church of Lewisville, located north of the commercial district on Church Street, served many prominent members of the community. Sadly, the building did not survive progress. The current location of the First Baptist Church is on Valley Ridge Boulevard, not too far from where the congregation built its first church at Old Hall in 1869. (Courtesy James Polser.)

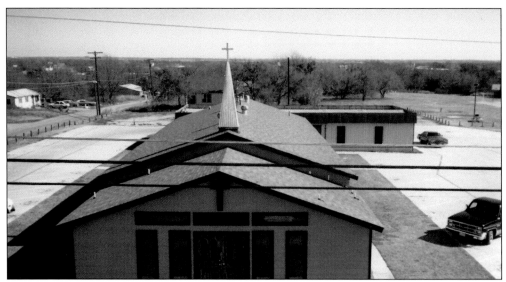

SOUTH BAPTISTS. The Macedonia Baptist Church, now called Macedonia Ministries, anchors Lewisville's historic African American neighborhood along Hembry Street in the southeastern section of town. Founded around 1880, the church has grown substantially in the ensuing years. This photograph depicts the second sanctuary, which was replaced in the 1980s by a larger structure. (Courtesy Macedonia Ministries, T.J. Denson, pastor.)

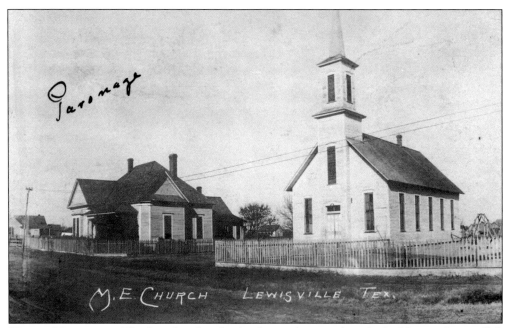

UNITED METHODISM. The first churches for Anglo worshippers shared a building in Lewisville's original location, which is where the Old Hall Cemetery now lies. As Lewisville grew into a commercial center, congregations built separate churches. The Methodists erected a wooden building with a prominent steeple along Church Street. (Courtesy Denton County Museums.)

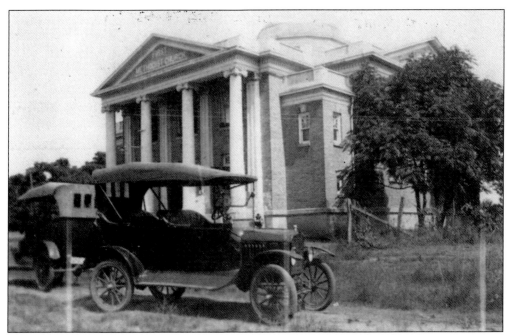

LATER METHODISM. The Methodist congregation built a more stately church in the 1920s. Notice the lack of sidewalks and paved roads in this photograph. Like the other churches in downtown, this building does not exist anymore. The congregation has moved to more modern facilities on Main Street west of Interstate 35 East. (Courtesy James Polser.)

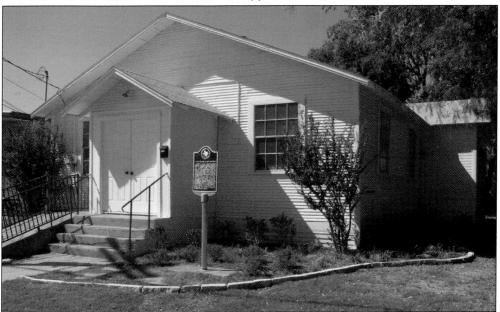

EPISCOPAL METHODISM. Because in its historic beginnings, the Christian Methodist Episcopal (CME) Church was open to lay preaching by enslaved people, many post–Civil War congregations tended to be predominantly African American. The Lane Chapel CME Church, located on Hembry Street, served freedmen in the Lewisville area and still boasts a small but active congregation. (Author's.)

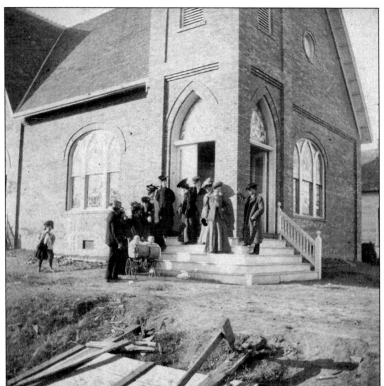

MEET AND GREET. In a town as small as Lewisville, schools, stores, and churches set the pace for the community. In this photograph, worshippers linger after service at the First Baptist Church to marvel at two twin boys from the Tarrington family. (Courtesy James Polser.)

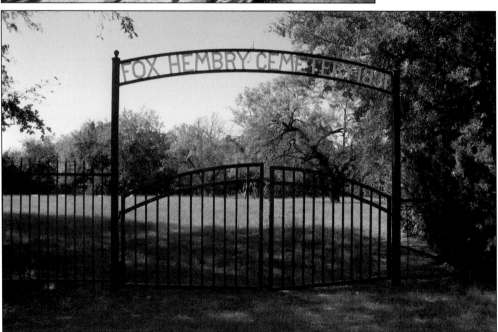

FINAL REST. In 1845, an enslaved child named in Malinda was buried in a small plot on the Fox farm. In 1895, an acre was deeded to A. Hembry, Will Nichols, Scott Fox, Word Watkins, and Muice Craft to serve as a "burying place for colored people . . . never to be used for any other purpose." Descendants continue to maintain the cemetery. (Author's.)

Two

FARMERS IN THE CITY
GROWING LEWISVILLE

Lewisville quickly became an economic hub as the decades progressed. The arrival of the railroads introduced more commerce, as did the extensions of roads throughout the county. While driving to Dallas still took the better part of a day at the beginning of the 20th century, by mid-century, a trip to Dallas, Fort Worth, or Denton could be accomplished in as little as half an hour.

The city's population consistently grew, as did Lewisville's housing market. The many open fields that surrounded the original city proved incentive enough for developers to expand the boundaries of the town. Lewisville became one of Dallas's premier suburbs; advertisers touted Lewisville's pretty location and its convenience to US Highway 77.

Lewisville's administration solidified itself during this period, too. In 1925, Lewisville incorporated into a city. In 1963, citizens voted in favor of home rule, which created a modern government with taxing authority, code adoptions, and a professional administrative staff that included a city manager.

With an active city government, a supportive chamber of commerce, several thriving businesses, and engaged citizens, Lewisville's prosperous future seemed assured. Yet even with the growth, the city still maintained its farming roots. The downtown feed mill continued to operate, farmers still harvested their crops, and longtime friends and family remained interconnected. At its roots, this burgeoning city was still a small town.

LEWISVILLE — "A CITY WITH A FUTURE"

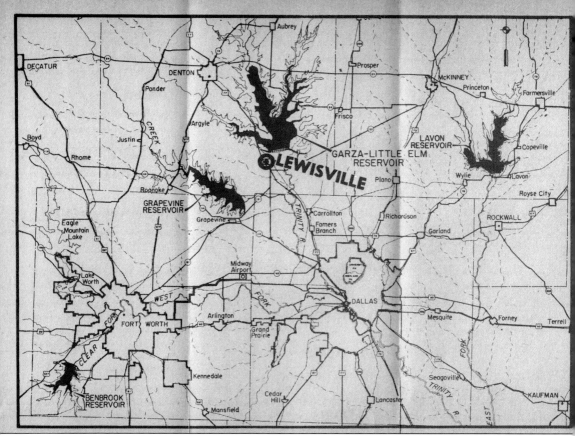

LOOKING UP. In the early 1960s, the city published a promotional map that put Lewisville in the center of North Texas. At this time, Lake Lewisville was still known as the Garza–Little Elm Reservoir. The city's slogan, "City with a Future," was an apt description for a town poised to grow to almost four times its size by the end of the century. (Courtesy James Polser.)

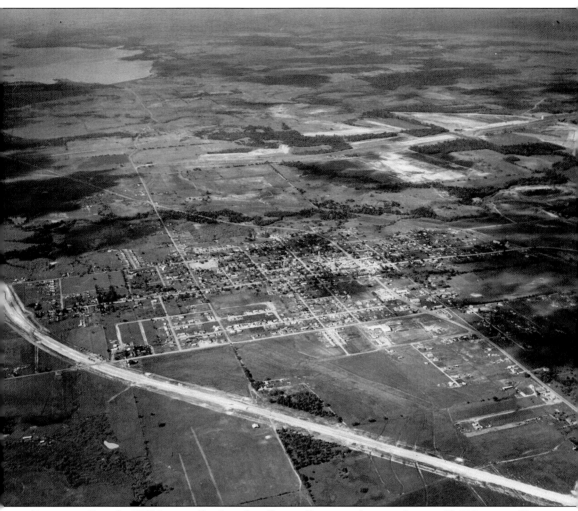

REACHING OUT. In 1955, Lewisville, though still a small town with a population of 2,200, saw itself quickly expanding. In this aerial photograph, the newly redesigned US 77 (later to become Interstate 35 East) snakes to the city's left. The construction of Lewisville High School, which in later years served as Delay Middle School, flanks Lewisville to the south. The dam of Lake Dallas, to the north, will soon be breached to create the much larger Lake Lewisville. The tracks of the newly constructed Santa Fe Railroad mark the city's boundary to the east. (Courtesy James Polser.)

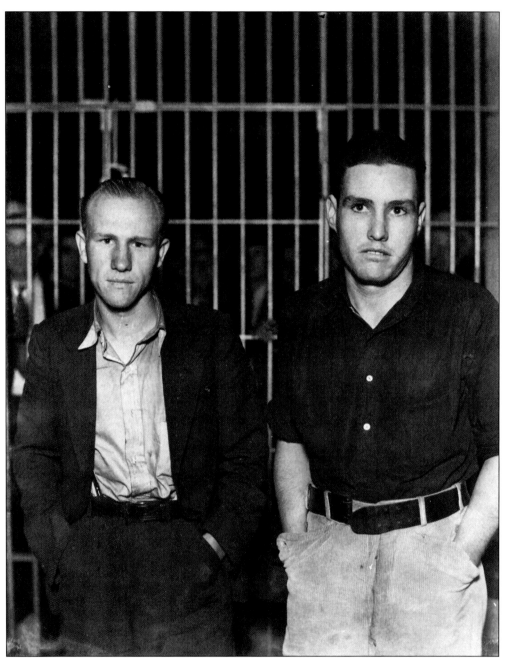

ROBBERS! During the 1930s, the Barrow Gang, headed by the notorious outlaw Clyde Barrow, hid out in an abandoned homestead between Lake Dallas and Lewisville. One of the gang's more famous members, Raymond Hamilton, made a name for himself by robbing banks, stealing cars, and successfully breaking out of prisons. The law caught up with Raymond (left) in Howe, Texas, after he robbed the First National Bank of Lewisville with a drifter, T.R. Brooks. Hamilton, charged with the murder of a store keeper in Hillsboro, received the death sentence. In 1935, he escaped from death row in Huntsville, killing a prison guard in the process. Within hours of his capture, he met his destiny on the electric chair. (Courtesy Dallas Public Library.)

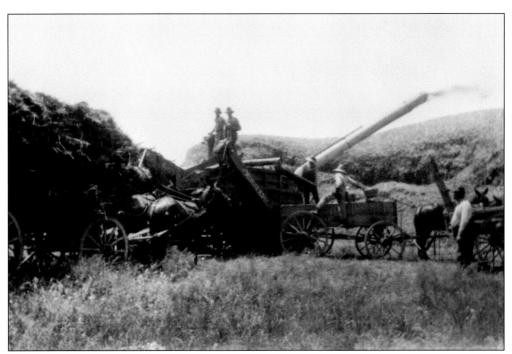

STILL FARMING. Even in the 1940s, farming still made up a large part of Lewisville's economy. These Lewisville-area farmers bale hay using a machine named the "Minnie Apollo." (Courtesy James Polser.)

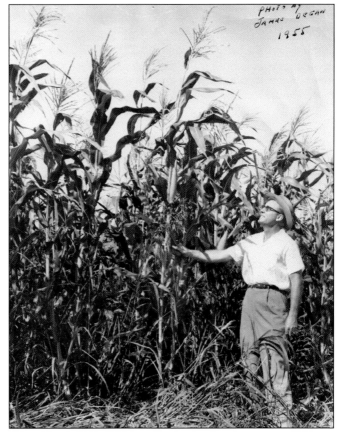

HIGH CORN. James Degan, co-owner of the Lewisville Feed Mill and descendant of the pioneer Degan family, stands in his cornfield in this 1955 photograph. Lewisville farmers continued to grow corn, peanuts, and grains well into the 20th century. The American Nut Company, which occupies the site of the former train depot, has used Lewisville peanuts to manufacture peanut butter since the 1950s. (Courtesy James Polser.)

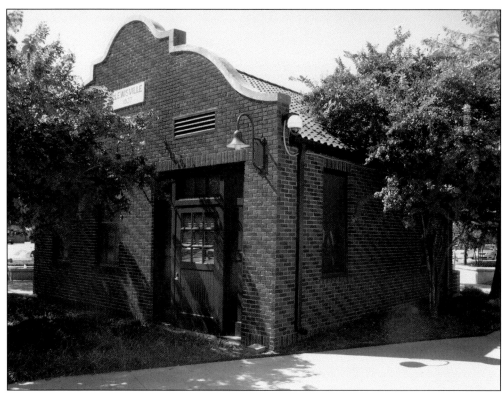

CITY BUILDING. Lewisville incorporated as a city in 1925, and in 1927, the first Municipal Building opened at the north end of Poydras Street. The "well house," as this building is now called, housed the constable's office, the water department, and the city's lone jail cell. The little building still sits in its original location but now graces the front entrance of a much larger city hall. (Author's.)

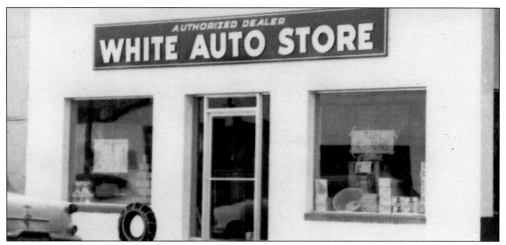

MOTOR CITY. The White Auto Store, located at 108 East Main Street, was one of several stores in downtown Lewisville that offered automobile parts and services in the 1950s. (Courtesy Denton County Museums, *Denton Record Chronicle* Collection.)

GROCERIES IN TOWN. Crawford's Super Market was one of Lewisville's first "convenience stores" that featured self-service and shopping carts. It was located in downtown Lewisville at the corner of Main and Mill Streets. When strip centers, with better parking, became the preferred way to shop, most grocery stores left downtown in the 1970s. (Courtesy Denton County Museums, *Denton Record Chronicle* Collection.)

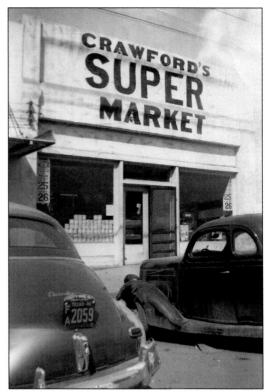

CHANGING NAMES. In 1955, Elmer E. Williams from Dallas purchased the brick building and general store that belonged to Joseph Cobb, who sold groceries, china, glassware, and bricks. Gayle Albritton owned Western Auto, located next to the Elmer Williams Store on the southern side of Main Street. (Courtesy Denton County Museums, *Denton Record Chronicle* Collection.)

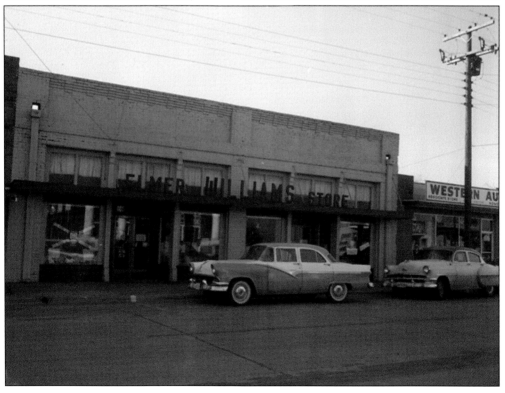

DRY CLEAN. The sign for Cobb's Cleaners hung above the storefront at 132 West Main Street. Before that, the building housed the Daddy Merritt Café and the Chambers & Orr Drugstore. Jeff Cohen took this photograph for the *Lewisville News* in the early 1990s. (Courtesy Denton County Museums, *Denton Record Chronicle* Collection.)

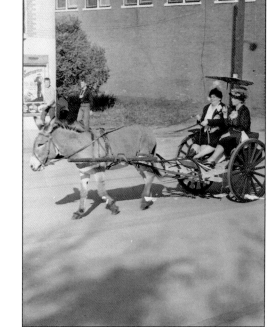

OLD TIME FUN. Fay Brooks and Mrs. Lewis take a donkey cart on a nostalgic trip down Main Street in this late-1940s photograph. Andy's Theater promotes the well-received movie *Gunfighters* in the window. (Courtesy James Polser.)

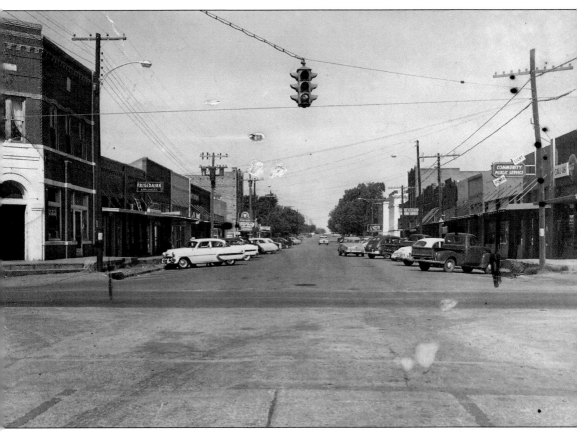

MAIN AND MILL. Lewisville's first stop light, at Main and Mill Streets, is giving the "green" in this late-1950s photograph. The Community Public Service Office, located on the north side of Main Street, took care of electric power to the city's residents before deregulation and large power companies changed electric delivery. (Courtesy Denton County Museums, *Denton Record Chronicle* Collection.)

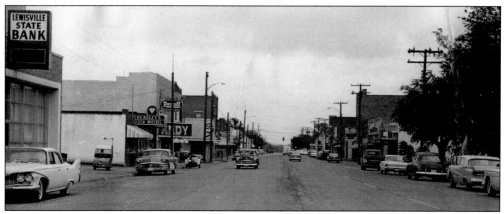

EAST MAIN. The following buildings are shown on the north side of Main Street in the late 1950s, looking east: Lewisville State Bank, which opened in 1946 and featured the county's first drive-through; Beasley Jewelry Store, which replaced Metlock's Jewelry Store; Rexall Drugstore, featuring a soda fountain; and Andy's Theater. (Courtesy Denton County Museums, *Denton Record Chronicle* Collection.)

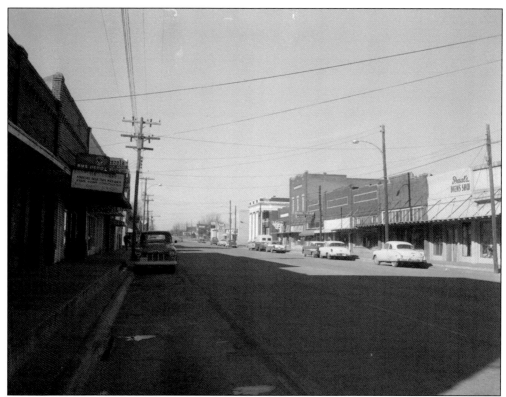

WEST MAIN. The following stores are included in this scene on Main Street in 1958, looking northwest: Joe C. Cobb's Store, which earlier occupied a large storefront across the street; Moore Drugstore, which opened in 1911; the First National Bank Building; and Andy's Theater, which burned in the 1960s. Continental Trailways Bus Depot, Hill's Cleaners, and Milligan's TV Shop grace the south side. (Courtesy Denton County Museums, *Denton Record Chronicle* Collection.)

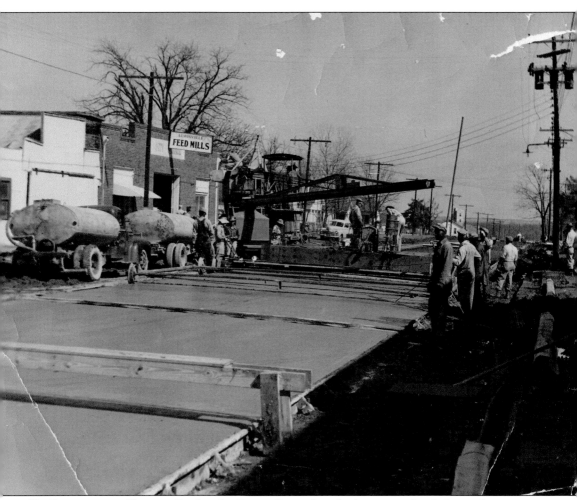

BIG LEAP INTO THE FUTURE. For decades, Lewisville residents had to contend with dirt roads—even old US 77, which came through town in the 1920s, was clogged with dust. In 1956, state and local funding allowed the paving of Main Street all the way to the railroad tracks to the east and to the new superhighway US 77 to the west. (Courtesy James Polser.)

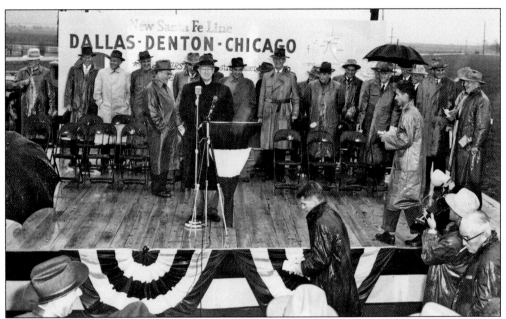

MAKING TRACKS. At mid-century, the Gulf, Colorado, and Santa Fe Railroad constructed a new, 49-mile-long route that linked Garland (Dallas County) to Sanger (Denton County). The tracks passed through the north side of Lewisville, just south of what would be known as the Lake Lewisville Dam. In 1954, dignitaries inaugurated the new line in Denton. Today, the Kansas City Southern uses the line. (Courtesy Denton Public Library.)

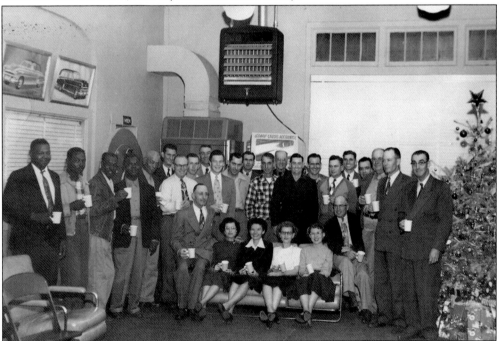

CHRISTMAS PARTY. Huffines employees celebrated the holidays in style in the 1950s, complete with an aluminum Christmas tree. Company founder J.L. Huffines sits on the left arm of the sofa. (Courtesy James Polser.)

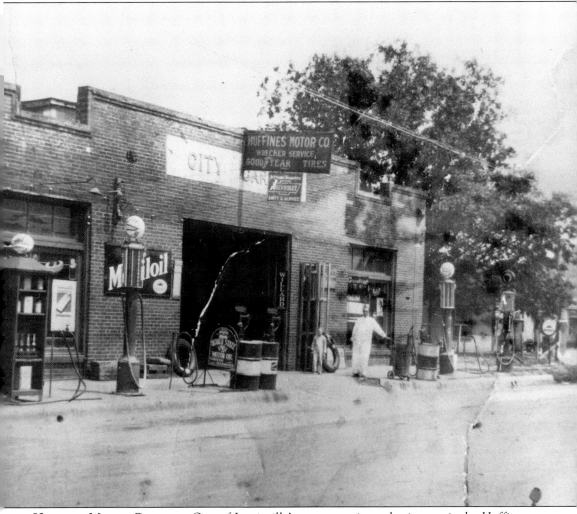

HUFFINES MOTOR COMPANY. One of Lewisville's most prominent businesses is the Huffines Motor Company, founded by J.W. Degan and J.L. Huffines. J.W. Degan opened the livery stables at the northeast corner of Mill and Main Streets in 1886 and added a feed store in 1907. In 1927, Degan rented the livery stable to J.L. Huffines to expand their fledgling Chevrolet dealership. Huffines bought the franchise and expanded it in 1932 by tearing down the livery stable and adding the City Garage, where Ford Model Ts had been sold, to his complex of buildings along northeast Main Street. The old City Garage served as the Chevrolet service building until the Huffines Motor Company moved from downtown to a more prominent location on Interstate 35 East. (Courtesy James Polser.)

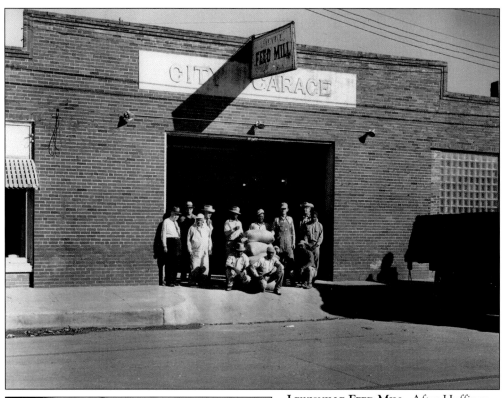

LEWISVILLE FEED MILL. After Huffines vacated it, Carl and James Degan's feed mill occupied the City Garage. From left to right, (kneeling) Lewis Champion, Leon Champion, and Raymond Champion; (standing) Carl Degan, Paul Berndt, Willie Harris Sr., unidentified, Harlee Hare, Mecal Brown, Leroy Germany, Fred Duwe, and Joseph Simpson pose in front of the feed mill in this late 1950s photograph. (Courtesy James Polser.)

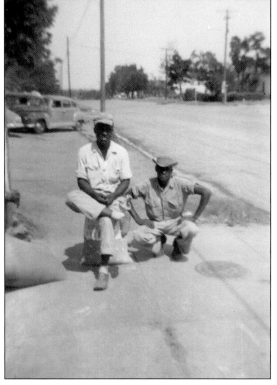

LONGTIME FRIENDS. The Lewisville Feed Mill employed local men who stayed at the mill for many years. Pictured here are Ronald Mayers (left) and Leon Champion. Champion's brothers, Lewis and Raymond, were also employed at the feed mill. And until arthritis forced him to retire, another person on the payroll, Harlee Hare, worked at the feed mill for 50 years. (Courtesy James Polser.)

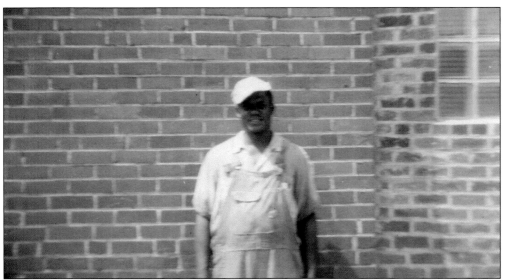

MR. BROWN. Another longtime feed mill employee was Mecal Brown. Brown, a lifelong Lewisville resident, retired from the feed mill in the 1990s. (Courtesy James Polser.)

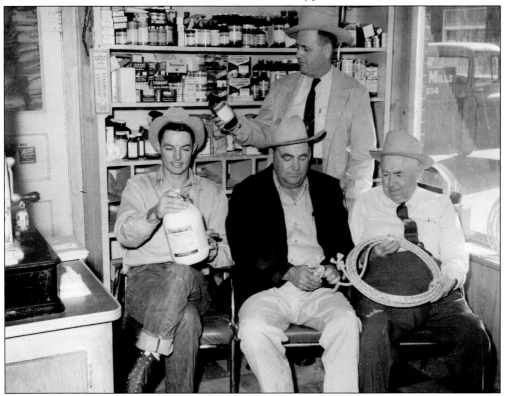

THE FEED BUSINESS. The Lewisville Feed Mill sold almost any product for pets and farm animals, as well as gardening supplies like fertilizer and pesticides. In this 1957 photograph, Bob Rheudasil (standing) and, from left to right, Morris Lord, James Degan, and Carl Degan show off some of the items for sale. Bob Rheudasil, a native of Paris, Texas, served as Flower Mound's first mayor. (Courtesy James Polser.)

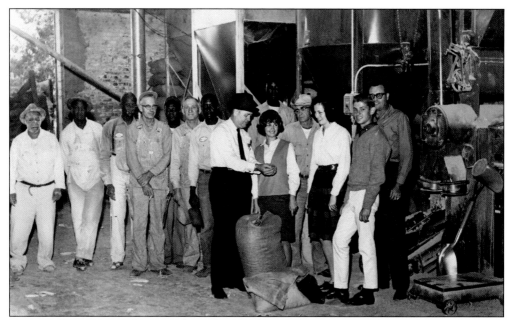

FUTURE FARMERS. Helping to keep Lewisville's farming roots relevant became a main mission for the owners of the Lewisville Feed Mill. In this 1964 photograph, from left to right, Willie Harris, Harlee Hare, Allen White, I.H. Wolters, Mecal Brown, James Degan, Woodrow Jones, Carl Degan, and J.H. Patterson explain things to three Lewisville High School students and their teacher. (Courtesy James Polser.)

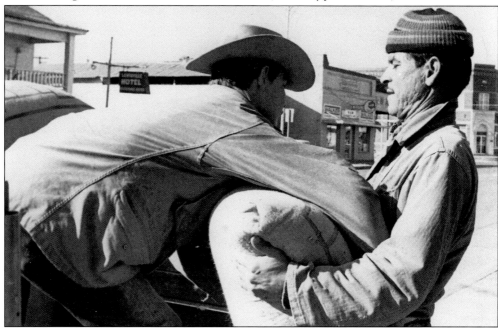

HELPING HAND. Lewisville students have been sponsored by the Lewisville Feed Mill numerous times, whether it was for the yearbook, parade floats, or—like in this photograph—for vocational training. Sandy Davis (left) worked at the feed mill for class credit in the 1970s. (Courtesy Denton County Museums, *Denton Record Chronicle* Collection.)

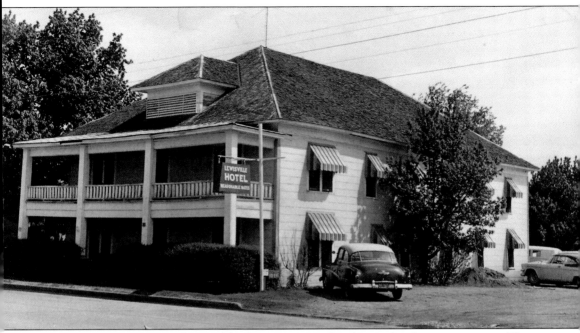

Place to Stay. The Lewisville Hotel, built in 1898, served male travelers from its inception. The restaurant downstairs provided hearty meals that attracted railroad workers and cowboys to downtown Lewisville. Sadly, the hotel burned in 1976. (Courtesy Velma McDonald and James Polser.)

EVENTFUL STAYS. Velma McDonald, who lived in this trailer when she operated the Lewisville hotel, remembered many strange and funny incidences. She once inadvertently rented a room to a wanted bank robber, had to warn everyone about a rabid dog, and helped break up a gambling ring. She also hosted a wedding for one of her renters. (Courtesy Velma McDonald and James Polser.)

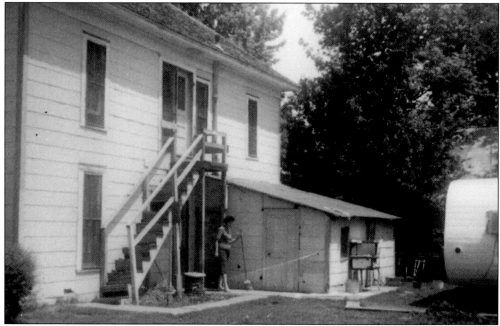

LADY OF THE HOUSE. Velma McDonald, seen in this photograph, recalled that the hotel still had its original gas heating, claw-foot tubs, and hitching posts when she and her husband bought the building in 1960. After her husband died, Velma McDonald ran the hotel as a male boarding house, offering the renters a homey atmosphere with games, free coffee, and television. (Courtesy Velma McDonald and James Polser.)

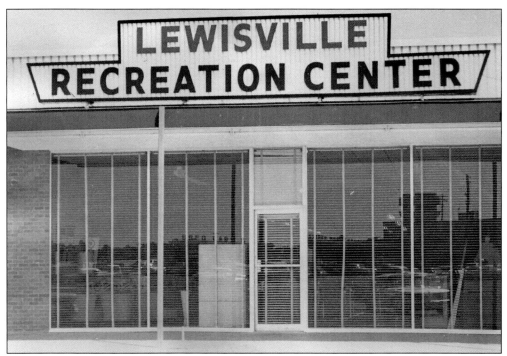

LEISURE TIME. As Lewisville grew from a town into a real city, administrators added many services for their citizens. The Lewisville Recreational Center was not the first of its kind in Lewisville, however. In the 1930s, the Works Progress Administration built a community hall and recreational center at the northern side of Church Street between Poydras and Charles Streets. (Courtesy Denton County Museums, *Denton Record Chronicle* Collection.)

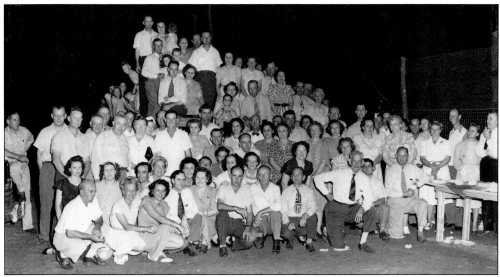

LION GET-TOGETHER. The Lewisville Lion's Club has served the community for many decades. This charitable organization sponsors the annual Highland Village Hot-Air Balloon Festival at Lewisville Lake. Pictured in this 1940s photograph are the Polsers, Wolters, Degans, Duwes, Gentrys, Huffines, Hayes, Edwards, Cobbs, Seagroves, Robertsons, Whatleys, Moores, Salmons, Whites, Howards, Parks, Williams, Crawfords, Siglers, Savages, and Nixes. (Courtesy James Polser.)

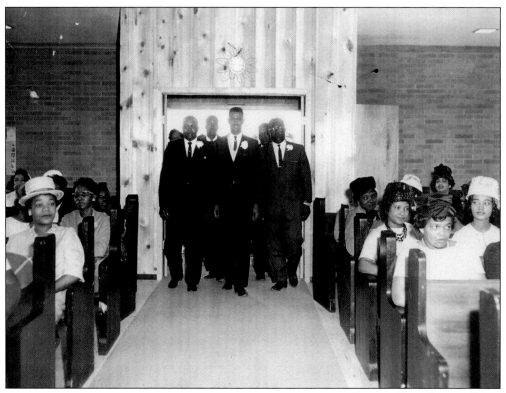

SUNDAY BEST. Lewisville's religious communities played a big role in the growth of the city. Macedonia Baptist Church's congregation was already outgrowing its sanctuary by the 1960s, when this photograph was taken. Today, the church has become a major missionary ministry. (Courtesy Macedonia Ministries, T.J. Denson, pastor.)

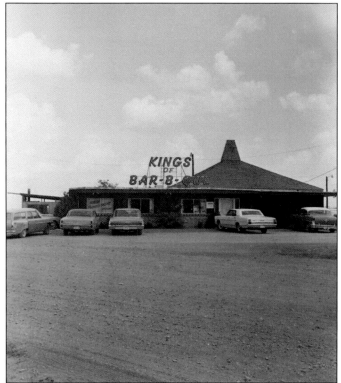

GOOD EATS. The Kings of Bar-B-Que restaurant, photographed in 1967, was one of Lewisville's favorite hangouts, like Groves Café, the Dairy Mart, and Ken's Royal Drive-In. (Courtesy Denton County Museums, *Denton Record Chronicle* Collection.)

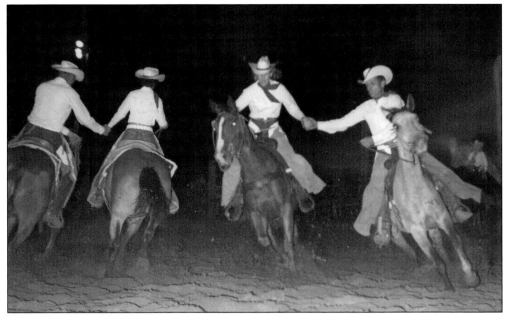

WESTERN DAYS. Lewisville's agricultural past was on display when the Lewisville Saddlers showed their cunning at the annual rodeo. Before 1945, rodeos took place on the field behind south Main Street, where the football team practiced as well. Today, the Lewisville Saddle Club, organized in 1962, hosts yearly rodeos at their arena on North Mill Street. (Courtesy Denton County Museums, *Denton Record Chronicle* Collection.)

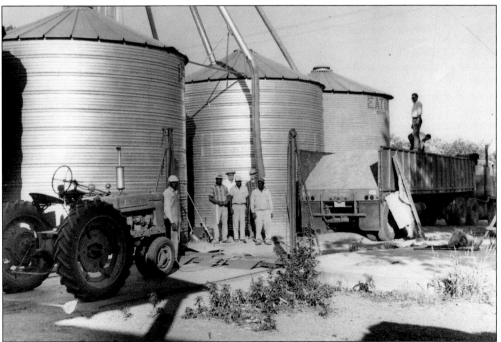

FEED STORAGE. The silos behind the Lewisville Feed Mill continued to operate throughout the 20th century. Customers could buy chicken, horse, and cattle feed, as well as fertilizer for their gardens. (Courtesy James Polser.)

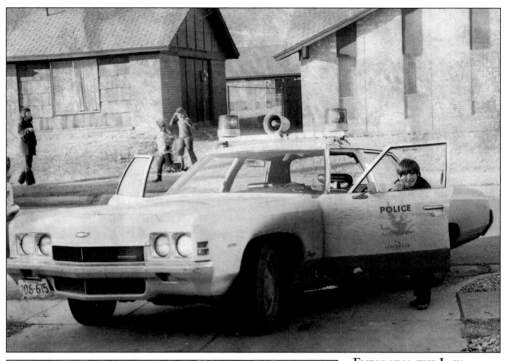

ENFORCING THE LAW. Early Lewisville employed only one constable and a few night watchmen. Later, a citizen's police force guarded the town. By 1973, the Lewisville Police Department took a more professional approach by hiring certified peace officers and dispatchers. In 1984, the Law Enforcement Building at corner of Main and Valley Streets opened. (Courtesy Denton County Museums, *Denton Record Chronicle* Collection.)

TWISTER! A tornado visited Lewisville during the 1950s. The winds wrecked havoc in the southwestern portion of the city, mostly to outbuildings like barns and patios. Fortunately, no lives were lost during the storm. (Courtesy Denton County Museums, *Denton Record Chronicle* Collection.)

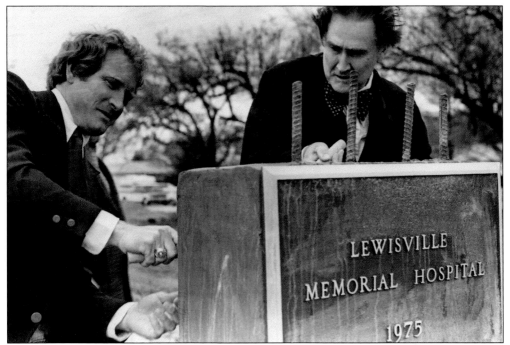

NEW BEGINNINGS. Before Lewisville Memorial Hospital opened in 1975, most Lewisville residents were born at Flow Hospital in Denton. That changed in 1977, when Stephanie Marie Clark became the fist baby born in Lewisville since hospital births became standard. (Courtesy Denton County Museums, *Denton Record Chronicle* Collection.)

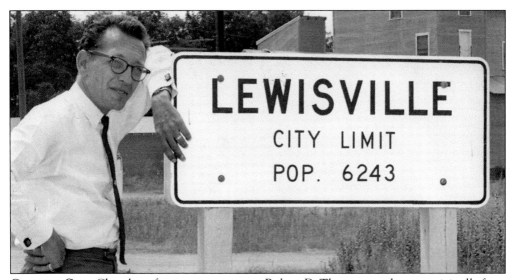

GROWING CITY. Chamber of commerce manager Robert D. Thompson, who was originally from Illinois, poses beside a population sign in this 1964 photograph. From 1962 to 1964, Lewisville added eight new industries to its economic base, which led to further demographic growth. (Courtesy Denton County Museums, *Denton Record Chronicle* Collection.)

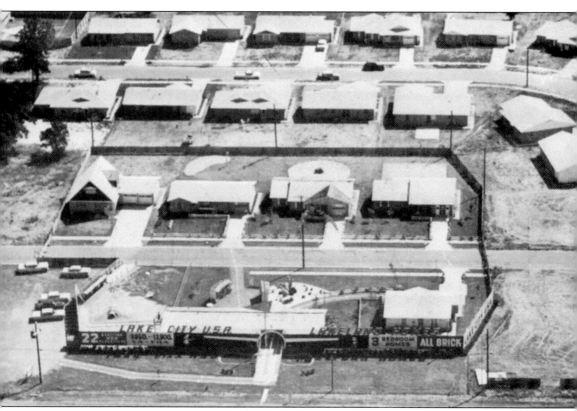

DEVELOPING WEST. Not every Lewisville resident was pleased when superhighway US 77 expanded into Interstate 35 East. While those who commuted to jobs in Denton and Dallas welcomed the convenient road, others wanted to preserve the small-town atmosphere of Lewisville. Regardless, Lewisville soon expanded. In the early 1960s, Harvey Deutsch opened the city's first planned community, which was just west of the interstate and only "fourteen miles north of the Tom Fields Circle" (also known as the Harry Hines Circle north of downtown Dallas). Brick houses with three bedrooms and two baths, a garage, and a spacious yard could be bought for around $12,000. Surf Street, Lakeland Drive, and South Lake Shore Drive mark the original boundaries of this neighborhood that eventually included over 2,000 homes. (Courtesy Denton County Museums.)

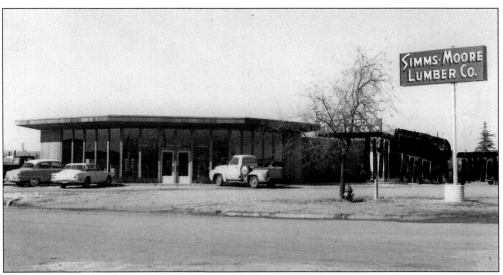

CONSTRUCTION BOOM. Seemingly since its inception, Old Town Lewisville has had lumberyards to accommodate its booming growth. The Simms-Moore Lumber Company stood at the northwest corner of Mill and Purnell Streets, where today, Mallard Supply sells all kinds of construction materials in addition to lumber. (Courtesy Denton County Museums, Denton Record Chronicle Collection.)

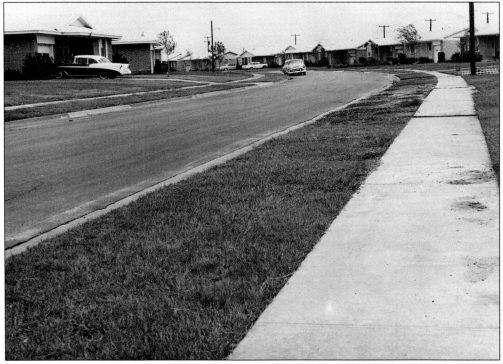

SUBURBAN COMMUNITY. By the 1960s, Lewisville was growing beyond its original borders. The city's strategic location near Dallas and Fort Worth, plus its reputation as a recreational center, made Lewisville a sought-after suburb. (Courtesy Denton County Museums.)

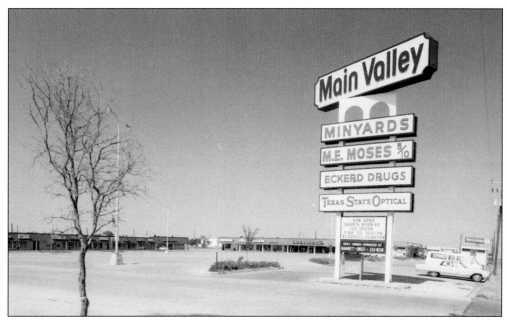

NEW SHOPPING. The new shopping center at West Main and Valley Streets, just across the street from the new Lewisville High School, offered amenities to shoppers that downtown lacked—ample parking, convenience to stores, and multiple entrances and exits. Soon, Old Town Lewisville found it could not compete with the car-centric culture of the modern suburb. (Courtesy Dallas Public Library.)

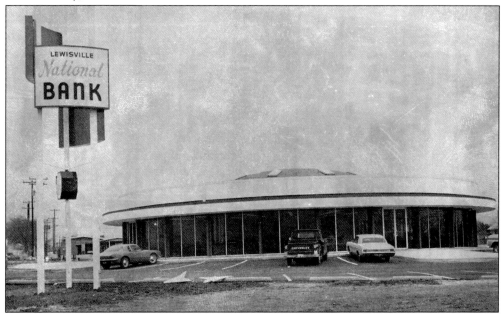

MODERN BANKING. In 1963, the Lewisville National Bank opened at the Lewisville Shopping Center on Mill Street. In 1969, the bank erected this round, ultramodern building on the southeastern side of Interstate 35 East and Main Street. Irving architects Grogan and Scoggins designed this homage to the space age that has since been torn down. (Courtesy Denton County Museums, *Denton Record Chronicle* Collection.)

MODERN WOMEN. Mary Rankin, left, and Grace Bolin, right, worked as tellers at the Lewisville National Bank and eventually were promoted to vice presidents. In a man's world, their accomplishments stood out, garnering mention in the *Who's Who of 1974*. Lewisville residents T.J. Turner, C.R. Kelly, A.I. Simpson, and Bill Howell served on the Lewisville National Bank Board of Directors. (Courtesy Denton County Museums, *Denton Record Chronicle* Collection.)

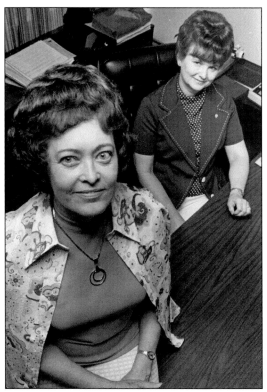

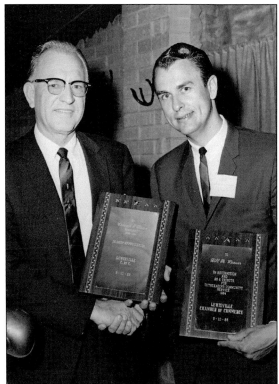

APPRECIATION. The Chamber of Commerce of Lewisville began in 1963 after the home rule charter, spearheaded by Dick Huffines, was approved. Here, chamber president Conrad Duwe and Lewisville mayor Bill Weaver show off their awards of appreciation at a banquet in 1968. (Courtesy Denton County Museums, *Denton Record Chronicle* Collection.)

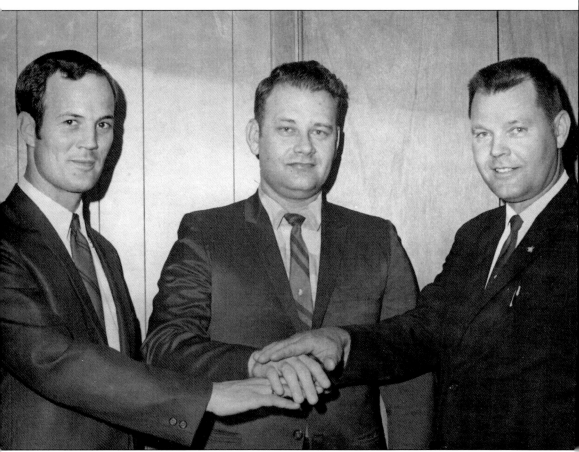

COMMUNITY LEADERS. In 1969, James Polser, pioneer descendant, lifelong Lewisville resident, and future owner of the Lewisville Feed Mill, was elected to the city council alongside David Richardson (right) and Mayor Sam Houston (center). Polser has become Lewisville's "unofficial historian," explaining that "if you know where you come from, sometimes you've got a better idea where you are going." (Courtesy Denton County Museums, *Denton Record Chronicle* Collection.)

Three

Fighting Farmers of Lewisville
Scholarly Lewisville

In the years prior to the Civil War, white Lewisville children saw their first schooling inside a small building located where Old Hall Cemetery is located today. When the 1876 Texas Constitution insisted that counties provide free public schools for all races, Denton County established several schools in 1877. Thomas E. Hogg, Denton County judge, granted two separate schools in Lewisville—one for whites and one for blacks.

Like all Southern states, Texas practiced segregation. In Lewisville, African American students attended Colored School No. 50, with Hoyle Day and Jack, Bill, and George Sheets as trustees. The small wooden school building was located at the corner of Purnell and Hembry Streets in the southeastern part of town. Those who attended high school had to travel to Denton, the county seat.

White students attended Lewisville School No. 14, with G.W. Morse, T.M. Clayton, and W.H. Graham as trustees. The first school was a wooden affair, but gradually the city built a brick building that included a high school. Lewisville Academy stood at the corner of Cowan and College Streets on the northwestern side of town.

With a constant influx of new students, Lewisville schools grew at a very fast pace. The sports teams adopted the name "Fighting Farmers" to reflect their heritage, and by the 1920s, the school had football and basketball teams. In the 1940s, the Texas Education Agency authorized special school taxing districts, and Lewisville Independent School District (LISD) commenced. Over the years, the district has grown to become one of the largest in the state. Today, the school district encompasses several towns. Two LISD high schools are located in Flower Mound, which lies west of Lewisville. The Colony (east) has a high school, as does Hebron (southeast).

Interestingly, while Lewisville is the largest city within the district, the city insists on having only one high school, even if its student body has to be dispersed to satellite campuses—the district and the city want to maintain their strong ties to each other. This provides every Lewisville student the opportunity to become a Fighting Farmer.

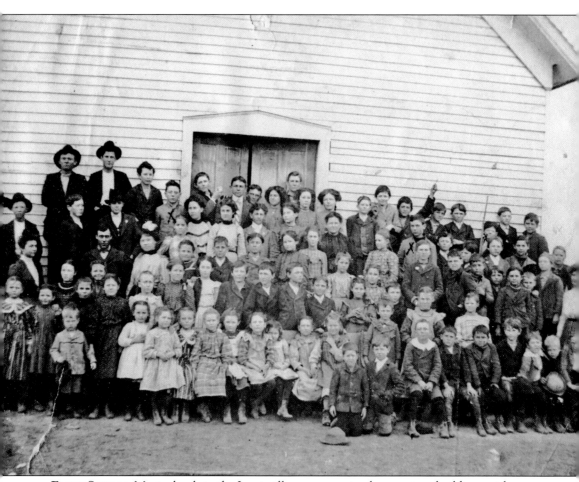

EARLY SCHOOL. Most schools in the Lewisville area were simple, one-story buildings with one or two rooms. This photograph of one of Lewisville's earliest schools may depict the schoolhouse that once stood at the town's original location on Holford's Prairie. (Courtesy James Polser.)

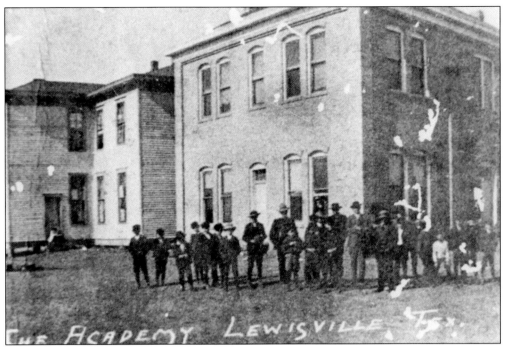

YEARN TO LEARN. Lewisville received land grants and monies for its first free public schools in August 1877 and its own high school in 1897. The large school buildings of the Lewisville Academy only served whites in this segregated system. (Courtesy James Polser.)

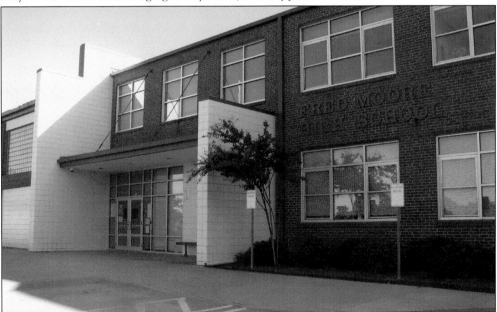

SEGREGATION. African American students attended a small, one-room schoolhouse at the corner of Purnell and Hembry Streets in southeastern Lewisville. The community named it the Lillie J. Jackson School in honor of a long-serving teacher. Until the 1960s, high school students had to take a bus to Fred Moore High School in Denton. Today, Fred Moore High School is an alternative education center. (Author's.)

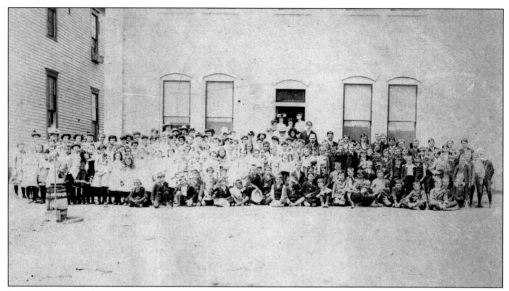

PUPIL POWER. The entire student body of the Lewisville Academy posed for a school photograph in 1901. Former students recalled that those who lived in town went home for lunch every day, while farm children brought their lunches. Many of the students went on to study at teacher colleges. (Courtesy Spencer family.)

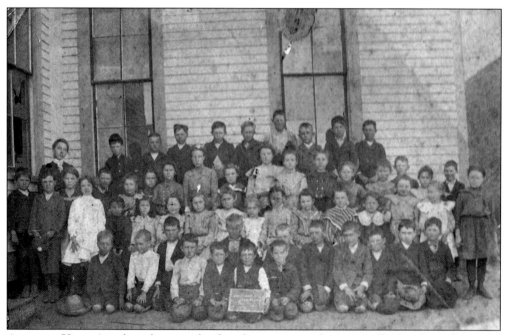

ACADEMY KIDS. Another photograph of students next to the Lewisville Academy shows the architecture of the school. High-reaching windows allowed the air circulate in the tall classrooms. The L-shaped wooden building, which stood next to a newer, two-story brick school, may have been the original school building. (Courtesy Denton County Museums.)

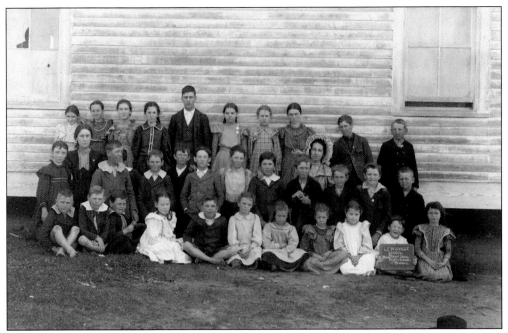

BEST DRESSED KIDS. Pictured in what looks to be their Sunday best, the students of Ms. Donnell and Ms. Chinn's class posed in front of the wooden building of the Lewisville Academy. The teachers are in the second row—Ms. Chinn is second from the left, and Ms. Donnell is wearing a bonnet. (Courtesy James Polser.)

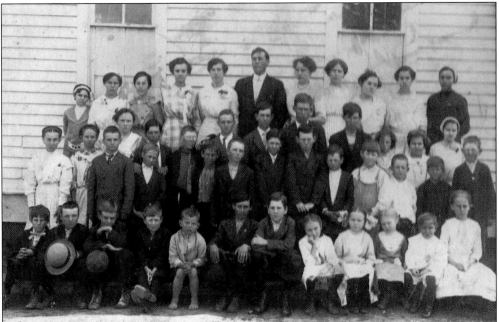

FARM KIDS. As the Lewisville School grew and more students wanted to take advantage of its sophisticated learning environment, smaller schoolhouses closed. The Lewisville School absorbed children from the Donald, Round Grove, Midway, McGurley, Lake, and Camey communities. (Courtesy James Polser.)

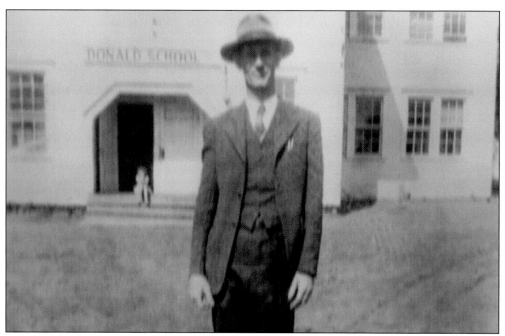

DONALD SCHOOL. Principal Raymond Banks of the Donald School, with student Helen Raines in the background, poses in front of his school in this 1937 photograph. Chartered in 1877, the Donald School, situated south of Farm to Market Road 1171 and Long Prairie Road, served students from the first grade to the 10th grade until 1940. (Courtesy Lewisville Independent School District.)

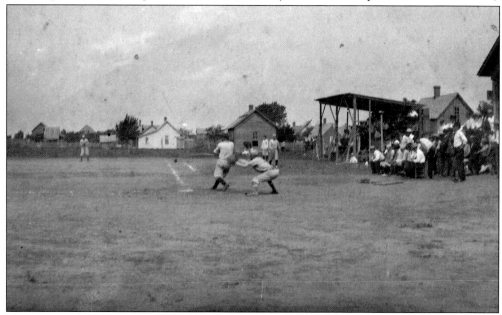

HOME RUN. The Lewisville Sluggers, comprised of high school students and amateur players, held games near the Lewisville Academy Building. Fans erected primitive stands just behind home plate to watch the game. At the turn of the century, when this photograph was taken, baseball had become the "national pastime," and all citizens enjoyed watching games in the middle of town. (Courtesy James Polser.)

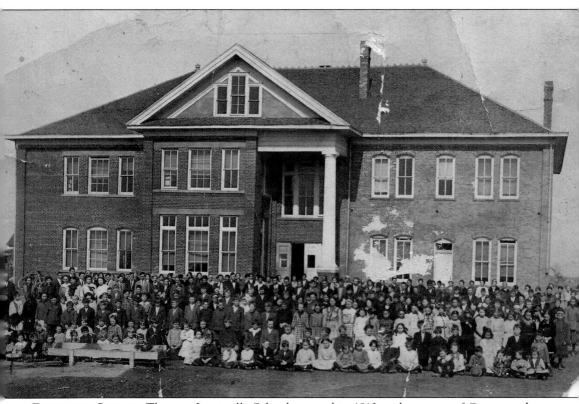

EXPANDING SCHOOL. The new Lewisville School, erected in 1912 at the corner of Cowan and College Streets, served white students in Lewisville until it burned in 1915. A newer school was built in 1921 and served the community until 1949, when a more modern high school opened on Purnell Street. Today, College Street Elementary occupies the site of the original Lewisville schools. (Courtesy James Polser.)

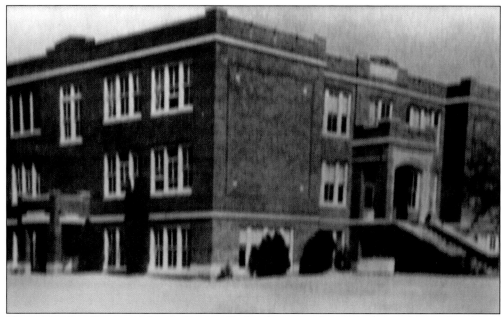

THIRD TIME'S A CHARM. After the Lewisville Academy was demolished to make way for a larger school, which burned down, Lewisville erected this modern building in its place. By 1950, when this photograph was taken, the school served only grades one through eight. High school students attended the new building on Purnell Street. (Courtesy Lewisville Independent School District.)

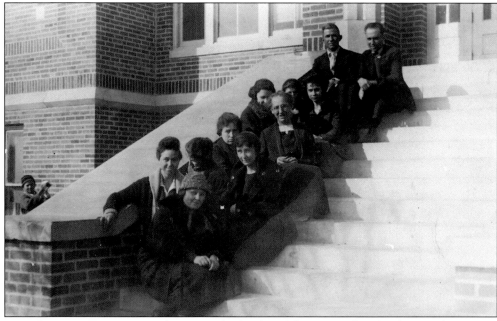

HIGH STEPPING TEACHERS. In the 1920s, the faculty of the Lewisville school sat on the steps to pose for a group picture. Sitting at the top of the stairs are Supt. B.F. Tunnell (left) and principal Lee Preston (right). Multi-talented Preston not only doled out discipline but also coached football and basketball. (Courtesy Denton Public Library.)

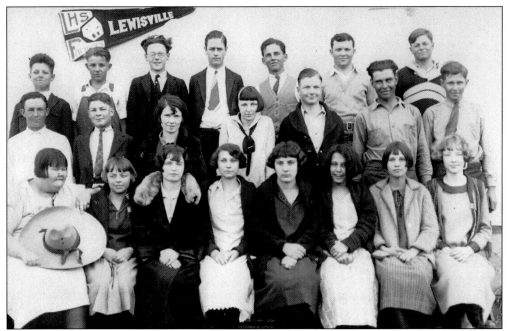

IN THE MODE. Flapper fashion and camaraderie are evident in this 1920s photograph of Lewisville High School seniors. Note the "bob" hairdos on the young ladies and the side parts, probably slicked back with Brill Cream, on the gents. (Courtesy James Polser.)

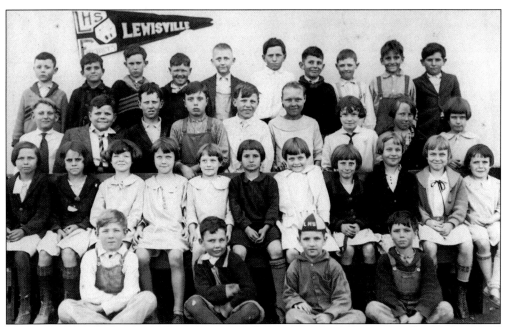

LEARNED KIDS. Gladys Fox, a descendant of the largest farm owners in Lewisville, taught second grade at Lewisville School in 1924. Fox, who began teaching at the age of 16, later earned her doctorate in English from Stephen F. Austin University and taught there for a number of years. (Courtesy James Polser.)

CLASS OF 1928. World events lay ahead of these well-dressed graduates of Lewisville High School in 1928, including a major economic depression and a second world war. Over the years, graduation ceremonies took place at local churches, the community center, and the gym of the modern Lewisville High School. Today, Lewisville students graduate inside the large auditorium on the campus of the University of North Texas in Denton. (Courtesy Peggy Bonds Cook, James Polser, and Lewisville Independent School District.)

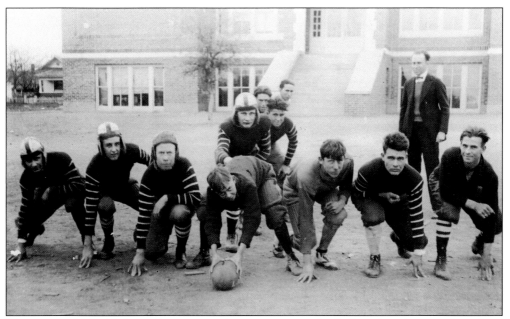

TOUCHDOWN! The Fighting Farmers are shown practicing football in this photograph in front of their new school building. Their coach was Lee Preston, who also served as their principal. (Courtesy James Polser.)

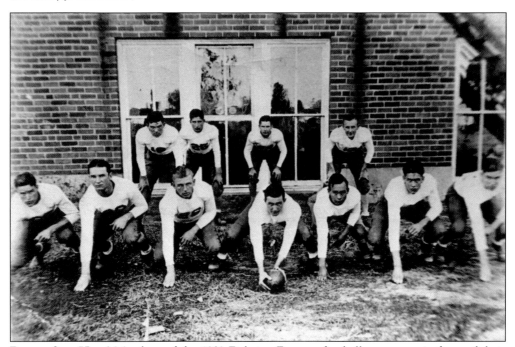

READY, SET, HIKE! Members of the 1932 Fighting Farmers football team pose in front of their school building. Pictured from left to right are (first row) Cornelius Sontagg, Doyle French, Pal Boyd, Bud Waldrip, Hoss "Fred" Williams, Woodrow Sigler, and Dick Hays; (second row) Henry Vance, Robert Jasper, Lee Bonds, and Woodrow Bays. Coach R.O. David watched their plays and their grades. (Courtesy James Polser.)

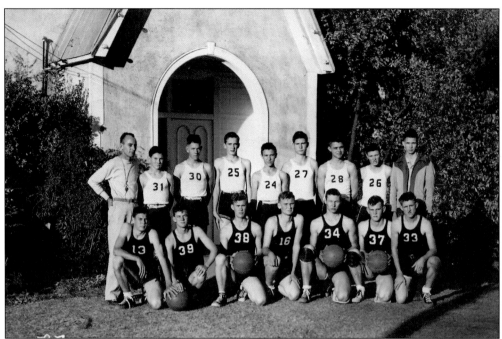

SLAM DUNK. The school's basketball team poses in front of the WPA-built community hall in this 1947 photograph. Those pictured are, from left to right, (first row) Marshal Durham, J.T. Langston, Cecil Edwards, Ronald McGatlin, Jerry Green, David Cundiff, and F.E. Bedell; (second row) coach Mack Bogard, Wesley Williams, Edward Henson, Johnny Whatley, Darrell Parker, Kenneth Williams, Wayne Frady, Billy Bush, and Billy Bond. (Courtesy James Polser.)

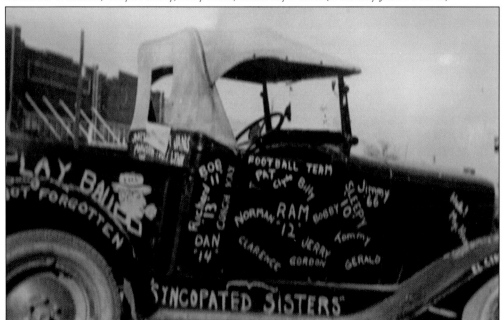

HOMECOMING. Decorated with the names of the football players, this old Ford truck took part in the 1953 homecoming parade in downtown Lewisville. (Courtesy Lewisville Independent School District.)

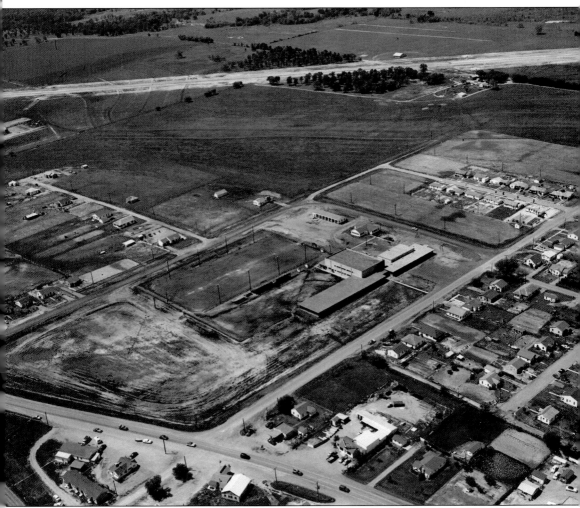

NEW HIGH. In 1948, Lewisville expanded south to build its new high school, set between Mill Street to the east, Purnell Street to the north, Charles Street to the west, and High School Drive to the south. Later, the school would be repurposed as the J.K. Delay Middle School, named in honor of the district's longtime superintendent. Today, this building has become an administration building. (Courtesy James Polser.)

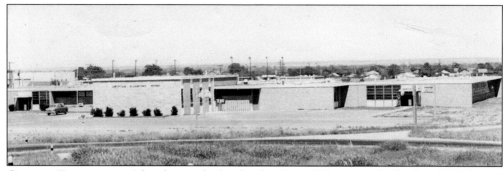

CENTRAL ELEMENTARY. After the new high school on Purnell Street was built, the school district constructed a modern elementary school with a library, cafeteria, and gymnasium. This 1954 building still serves Lewisville students today. Demographics have changed, however, and a majority of Central Elementary students are now Hispanic. (Courtesy Denton County Museums, *Denton Record Chronicle* Collection.)

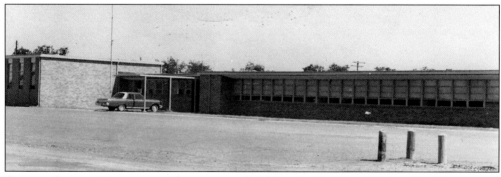

COLLEGE STREET ELEMENTARY. The two-story brick Lewisville School had outlived its purpose by late 1958, when the building was torn down. In 1960, the small and modern College Street Elementary School took its place. (Courtesy Denton County Museums, *Denton Record Chronicle* Collection.)

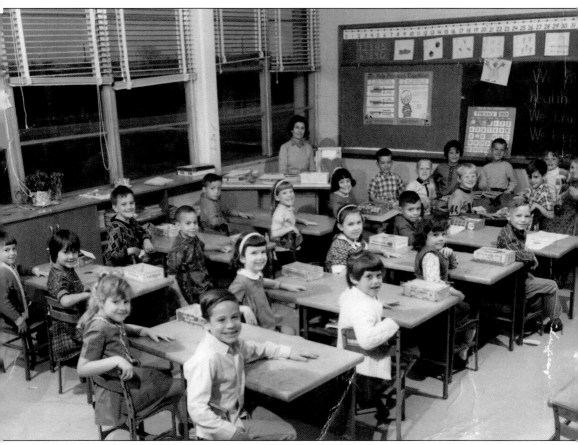

LAKELAND ELEMENTARY. The 1960s saw a dramatic increase in Lewisville's population, especially when the mega-development of Lake City enticed new residents. The Lewisville Independent School District responded by building Lakeland Elementary in 1964, the district's first school west of Interstate 35. Pictured is Eva Marie Atkins's first-grade class of 1967. (Courtesy James Crockett of Lakeland Elementary, Lewisville Independent School District.)

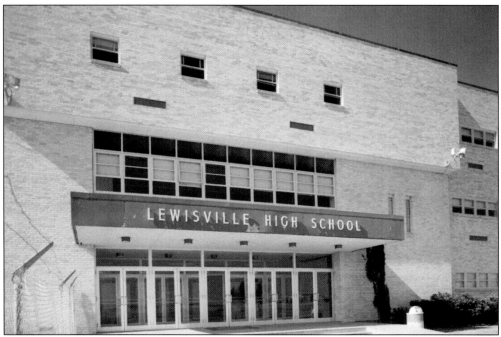

LEWISVILLE'S OWN. To this day, Lewisville High School serves all students who live within the city's boundaries, but due to population growth, the district has to be ingenious to accommodate so many students. In the 1990s, Lewisville built a campus solely for ninth-grade students. Still, all Lewisville students end up here, graduating from this venerable building. (Courtesy Dallas Public Library.)

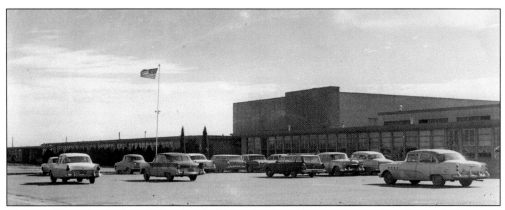

MODERN HIGH. By the late 1960s, the old high school could not accommodate the yearly increases in students. The school district constructed a new high school in the fields west of Interstate 35 at the corner of Main and Valley Streets. Today, this school centers Lewisville's "second downtown" near the library, government center, city swimming pool, and police station. (Courtesy Denton County Museums, *Denton Record Chronicle* Collection.)

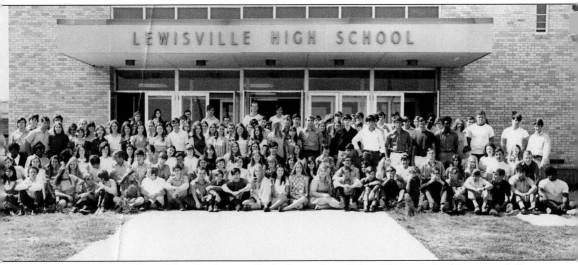

INTEGRATION. By the 1970s, the Lewisville Independent School District had become fully integrated. Desegregation was not an easy battle to win, however. Families sued the district to force integration, but the lawsuit was dismissed after the school district proved that it needed time to make space for the additional students. Within a year, Lewisville schools opened their doors to everyone, and the city finally had schools common to all races. (Courtesy Denton County Museums, *Denton Record Chronicle* Collection.)

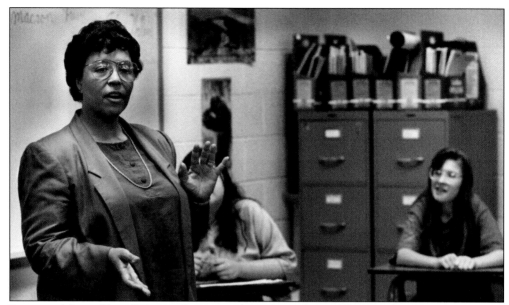

INSPIRING MINDS. Vernell Gregg, a longtime educator at Delay Middle School, teaches a class in this photograph by Matt Brunworth for the *Lewisville News*. Gregg was named Person of the Year by the Lewisville chapter of the NAACP in 1991. Gregg still influences education as a member of Lewisville's school board. (Courtesy Denton County Museums, *Denton Record Chronicle* Collection.)

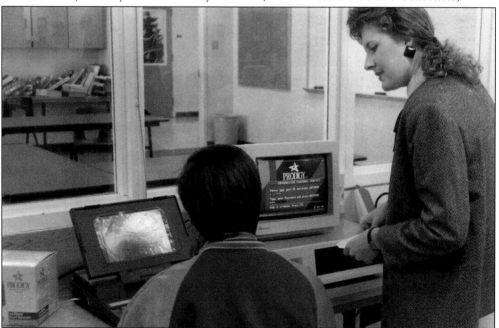

FUTURE ORIENTED. Lewisville Independent School District has been a longtime innovator in public education. The Dale Jackson Career Center is one of the district's great ideas. When it opened in 1985, students could learn computer programming, automobile mechanics, cabinet making, cosmetology, and welding. Today, its award-winning programs have expanded to include graphic design, electronics, and animation. (Courtesy Denton County Museums, *Denton Record Chronicle* Collection.)

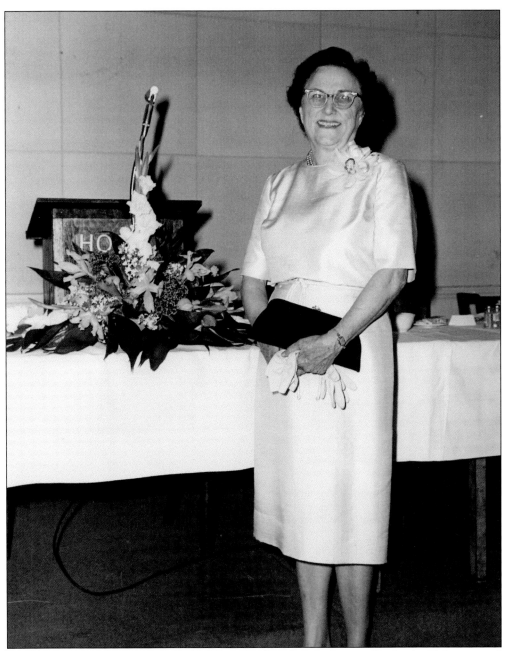

Dr. Fox. Pioneer-descendant Gladys Fox, who founded the Lewisville Study Club, received her bachelor's degree from the North Texas State Normal School in Denton, a master's degree from the University of Texas in Austin, and a doctorate from Stephen F. Austin University in Nacogdoches, where she taught English. In 1960, Dr. Fox accepted the Minnie Piper Stevens Foundation Award for Outstanding Scholarly and Academic Achievement. (Courtesy James and Virginia Polser.)

FOUNDING EDUCATOR. J.K. Delay served as Lewisville's superintendent from 1942 to 1966. Born in Millers Grove, Hopkins County, Delay received his degrees from East Texas Normal School (now Texas A&M University at Commerce). Before coming to Lewisville, the Palmer School District employed him as superintendent. Lewisville schools not only relied on Delay for managing the schools but also for coaching the football team—he remained the coach for several seasons until one was permanently hired. Delay saw much history in his tenure as Lewisville's top administrator, including the building of five new schools, the consolidation of outlying community schools into the Lewisville district, and the integration of African American children in 1963. (Courtesy Denton County Museums, *Denton Record Chronicle* Collection.)

Four

FARMERS ON THE WATER
LAKE LEWISVILLE

Lewisville is not only known for its outstanding school district and suburban growth—it is also prized as a recreational heaven. Lake Lewisville, situated just north of downtown, is one of the main sources of fresh water for North Texas residents and also a playground for boaters, fishermen, and swimmers.

The lake began as a much smaller reservoir along the Elm Fork of the Trinity River for the purpose of providing drinking water to Dallas residents. Built in 1928, its first incarnation was as Lake Dallas. The US Army Corps of Engineers expanded the lake in the 1950s. Several families gave up their farms for the proposed lake, and more had to be evacuated when the new lake filled up faster than expected during the record-setting rains in the late 1950s.

Expanding the lake caused quite a commotion when amateur archeologists from the Dallas Archeology Society explored the proposed lake bottom. The club uncovered several middens (ancient campsites), as well as a Clovis arrowhead. The Clovis culture, named after the site in New Mexico where evidence of their existence was discovered, is the oldest known Amerindian culture in North America. Archeologists from around the country took great interest in the site. However, it could not be properly examined until 1980, when a record drought exposed the drowned campsites once again. The new dig determined that the Lewisville area held inhabitants over 11,000 years ago.

While for decades Lewisville residents called the lake "Lake Dallas" and then the "Garza–Little Elm Reservoir," the US Army Corps of Engineers referred to it as Lewisville Lake instead. By the 1970s, Lake Lewisville became the lake's official name.

Lewisville is justifiably proud of the lake and the hundreds of acres of parkland surrounding it. A nature preserve on the south side of the dam allows hikers and fishermen to explore the Trinity River bottoms, and Lewisville Independent School District has created an outdoor learning center at the foot of the lake. On weekends, the lake hums with activity, making Lewisville a true destination city.

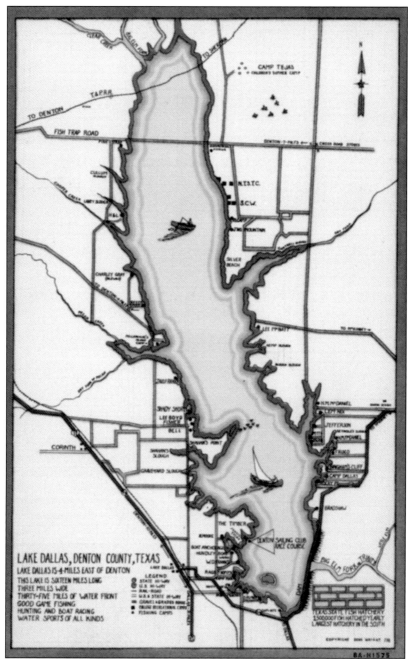

SEE LAKE DALLAS! The town of Garza changed its name to Lake Dallas to reflect its proximity to the lake. By the 1950s, Dallas realized that Lake Dallas's capacity proved inefficient, so the US Army Corps of Engineers expanded the lake to store more water, enhance flood control, and foster recreational activities. In this postcard of a primitive map drawn by Sena Mounts Wright, many of the lake's early features are shown, including the State Fish Hatchery, the Denton Sailing Club's racecourse, and Camp Tejas, a summer camp for children. Note that one could drive on the Garza Dam to reach Little Elm, Frisco, and McKinney. Today, drivers use State Highway 121. (Courtesy Denton County Museums.)

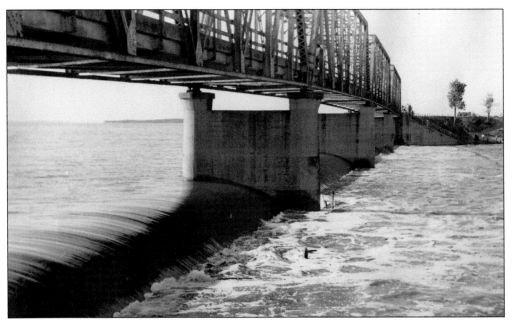

GARZA DAM. Built to supply water to the burgeoning city of Dallas, the Garza Dam, which created Lake Dallas, was completed in 1927 at a cost of $5 million. Between 1948 and 1954, workers built the Garza–Little Elm Dam at a cost of $23.4 million. This new dam would serve as a levee for the expanded Lake Lewisville. (Courtesy Denton County Museums, *Denton Record Chronicle* Collection.)

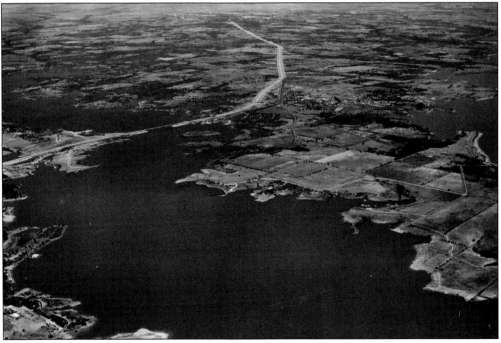

LAKE LEWISVILLE. The result of the expansion of Lake Dallas was Lake Lewisville. The lake continues to be the water supply for the city of Dallas, and Lewisville residents drink the lake water as well, though they have to pay an annual fee to Dallas for water rights. (Courtesy Denton County Museums, *Denton Record Chronicle* Collection.)

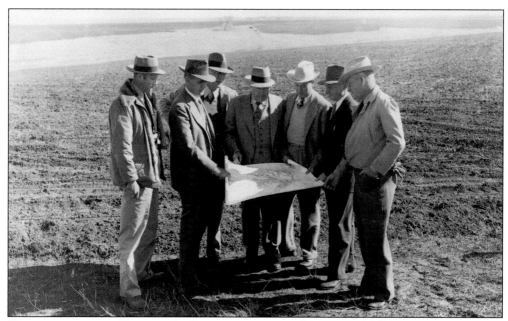

CONTEMPLATING THE FUTURE. Civil engineers, structural engineers, and county commissioners contemplate the extension of Lake Lewisville in this 1954 photograph. While most of the countryside south of Lake Dallas consisted of open prairie and farmers' fields, the lake's expansion did force a number of people to move. Many voiced disappointment with the paltry compensation received from the US government. (Courtesy James Polser.)

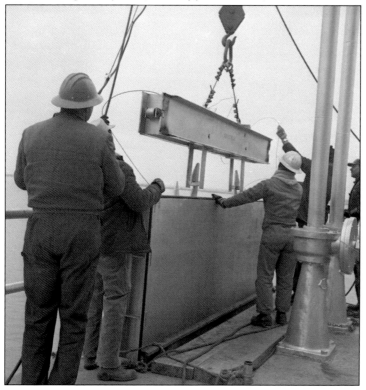

DAMMING THE NEW LAKE. In this 1954 photograph, workers fit steel beams into the Lake Lewisville Dam. (Courtesy Denton County Museums, *Denton Record Chronicle* Collection.)

DISMANTLING THE TRUSS. Drivers circumnavigated Lake Dallas by taking the road over the Garza Dam. The road's truss bridge had to come down in 1957 to make room for the lake's expansion. (Courtesy Denton County Museums, *Denton Record Chronicle* Collection.)

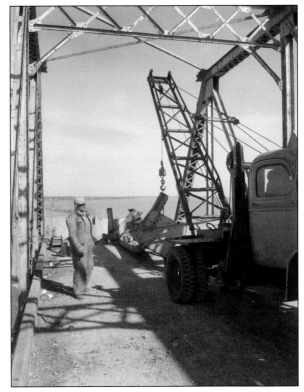

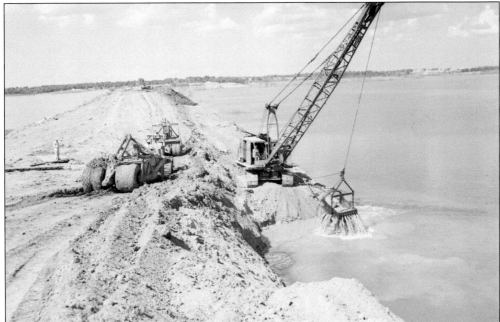

A LAKE IS BORN. Virgil McLarry, who would later work at the State Fish Hatchery in Lewisville, helped to build the dams of Lakes Texoma, Grapevine, and Lewisville. He recalled that construction took place day and night. In this 1957 photograph, workers are beginning to breach the old Garza–Little Elm Dam. (Courtesy Denton County Museums, *Denton Record Chronicle* Collection.)

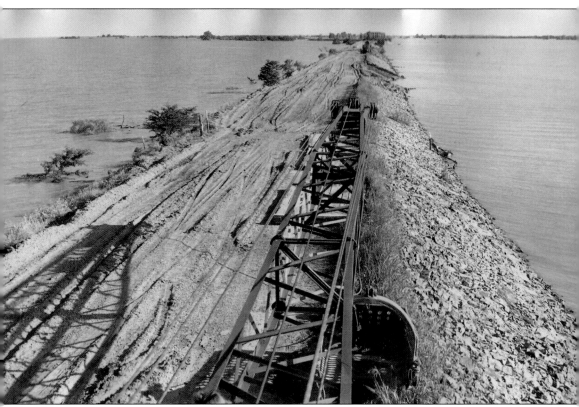

Water's Coming! Because of heavy rains in the seasons after the completion of the new Garza–Little Elm Dam, the US Army Corps of Engineers did not flood the newly expanded lakebed until 1957, when workers breached the old Garza Dam of Lake Dallas. Instead of the anticipated weeks, the lakebed filled in a matter of days, which spurred evacuation efforts for everyone south of the dam. (Courtesy Denton County Museums, *Denton Record Chronicle* Collection.)

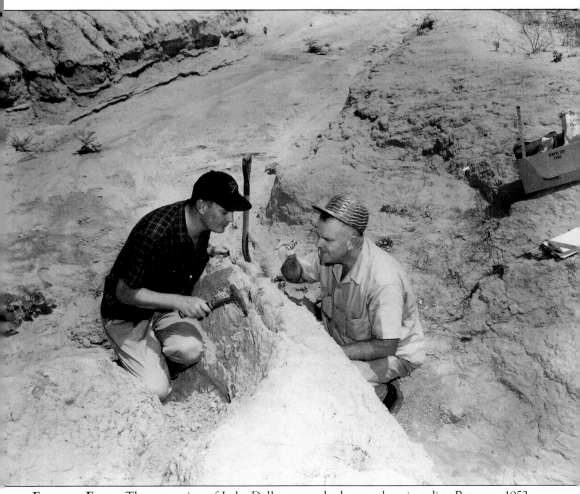

EXCITING FINDS. The expansion of Lake Dallas unearthed more than just dirt. Between 1952 and 1957, the Dallas Archeological Society found hearths and materials that suggested that the area around Lewisville may have been occupied 11,000 years before. In this photograph, Wilson W. Crook Jr. and R.K. Harris take scientific data from one of the ancient campsites. (Courtesy Denton County Historical Commission.)

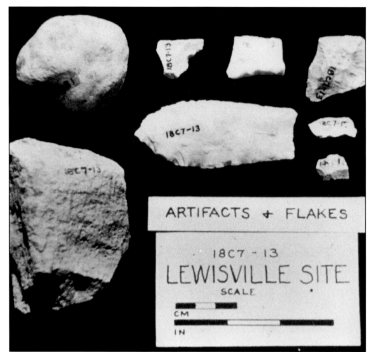

CLOVIS POINT. During their investigation, Dallas archeologists Wilson W. Crook Jr. and R.K. Harris discovered a large spear point known to have been used by the Clovis culture, a Native American tribal group that constituted the earliest known human settlement in North America. This amazing find excited archeologists from all over the continent, who wanted to study the site further. (Courtesy Denton County Historical Commission.)

RENEWED INTEREST. Lake Lewisville drowned the archeological sites, and it was not until 1980 that a drought allowed scholars access to the location once again. Archeologist Peggy Jordy's mission was to gather enough ancient, organic campsite debris so that she could accurately carbon date the stratum where Crook and Harris discovered the Clovis point. (Courtesy Denton County Museums, *Denton Record Chronicle* Collection.)

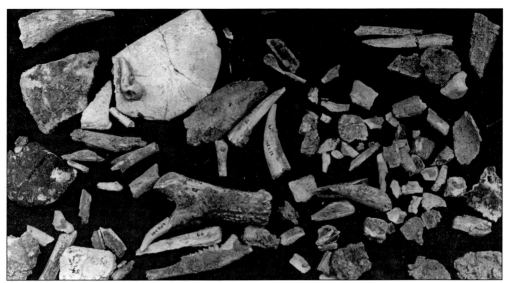

OLD TOOLS. In 1980, archeologists determined that the artifacts found in the stone-age campsites at Lake Lewisville were used 11,000 years ago, making Lewisville one of the oldest settlements in the Western hemisphere. (Courtesy Denton County Museums, *Denton Record Chronicle* Collection.)

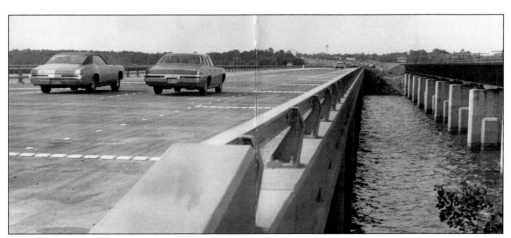

WATERY WAYS. The Corps of Engineers flooded US 77 when they expanded the lake in the 1950s. Thereafter, Lewisville residents had to rely on Interstate 35 as their northern thoroughfare. The tracks of the Missouri-Kansas-Texas Railroad ran alongside the interstate bridge. By 2011, those tracks are used by commuter trains traveling between Denton and Dallas. (Courtesy Denton County Museums, *Denton Record Chronicle* Collection.)

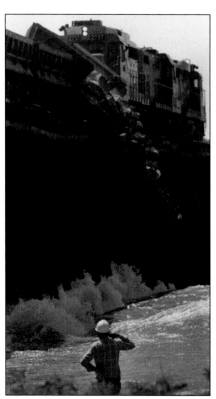

BREAKERS. In the 1980s, a locomotive pushes concrete waste into the lake off of the old Missouri-Kansas-Texas Bridge to enhance erosion control. (Courtesy Denton County Museums, *Denton Record Chronicle* Collection.)

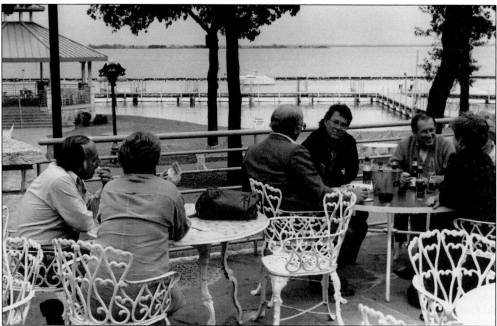

DINING BY THE LAKE. Lake Lewisville's ideal location—just minutes from downtown Dallas with convenient access—has helped foster a booming tourist trade. Sneaky Pete's, a marina and restaurant, is one of the successful businesses that line the shores of Lake Lewisville. (Courtesy Denton County Museums, *Denton Record Chronicle* Collection.)

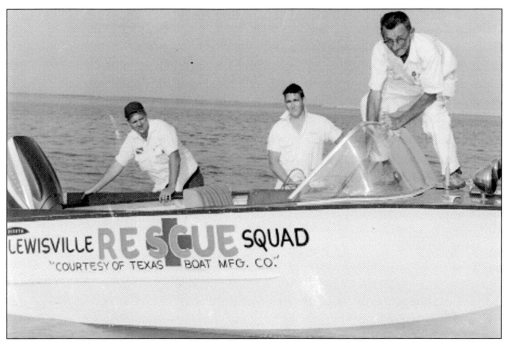

BAYWATCH. With the amount of visitors Lake Lewisville receives each year, accidents are bound to occur. Businesses and the city employ a rescue squad to mitigate such problems. In this 1960s photograph, volunteers man their stations aboard the Lewisville Rescue Squad boat. (Courtesy Denton County Museums, *Denton Record Chronicle* Collection.)

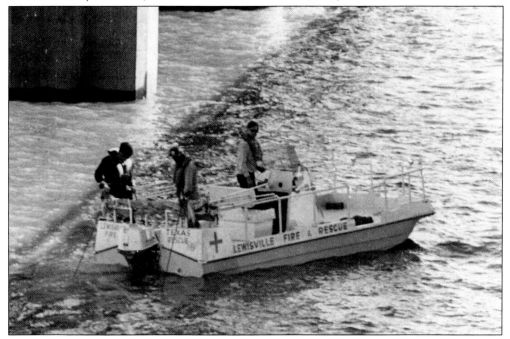

RESCUE MISSION. A fun day on the lake can become tragic in a mere instant. In this 1970s photograph, the Lewisville Fire and Rescue Squad searches for a missing swimmer. (Courtesy Denton County Museums, *Denton Record Chronicle* Collection.)

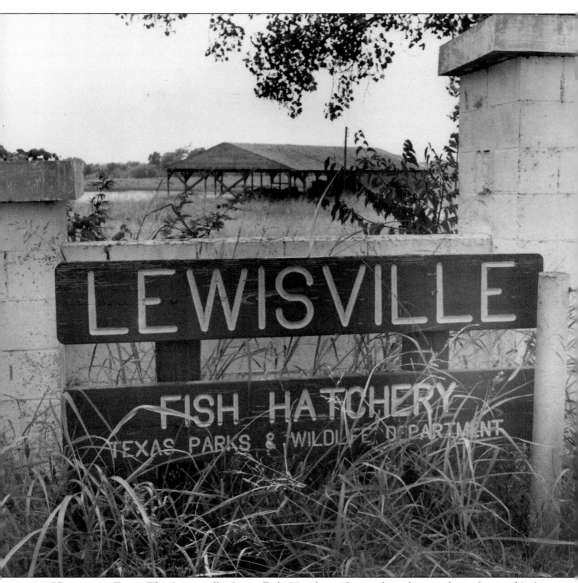

HATCHING FISH. The Lewisville State Fish Hatchery, located at the southern base of Lake Lewisville east of downtown, supplied crappie, catfish, sunfish, black bass, and bluegills to private and public lakes from 1952 until 1986. Employees and their families, like the Hastens, McLarrys, Pockruses, Searys, Baums, and Campbells, lived on site inside fully furnished rock houses. Virginia Hastens recalled that she loved living at the hatchery, where her husband kept up the grounds, monitored fish eggs, and delivered newly hatched fish. The fish hatchery occupied land vacated by dozens of Lewisville residents whose properties were bought by the Army Corps of Engineers when they expanded the lake in the 1950s. Today, the old fish hatchery serves as an outdoor learning center for Lewisville school students. (Courtesy Denton County Museums, *Denton Record Chronicle* Collection.)

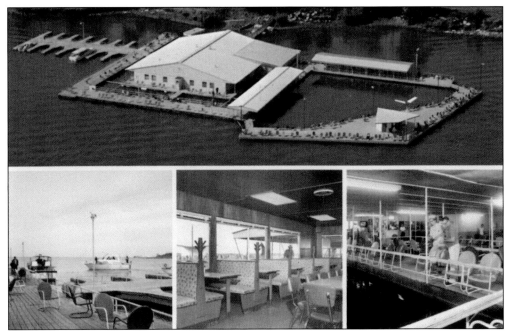

FISHING FUN. The Lake Lewisville Fishing Barge has been welcoming fishermen (and women) day and night since 1958. Visitors can fish for bass, catfish, and crappie either inside the 7,000-square-foot barge or outside on the docks. An indoor restaurant keeps anglers happy. (Courtesy Dallas Public Library.)

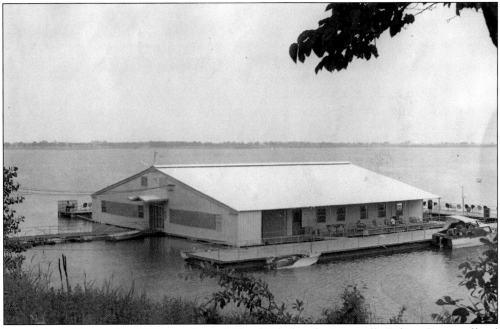

BARGE AHOY! Opened by J.W. Jagoe Sr. and Aland Whales, the Lewisville Fishing Barge suffered the effects of Hurricane Carla when she ripped through Lewisville in 1961. Lake Lewisville experienced 89-mile-per-hour winds and six-foot swells. (Courtesy Denton County Museums, *Denton Record Chronicle* Collection.)

FILL 'ER UP! Like automobile drivers, boaters can fill up on gas just by pulling up to a Lake Lewisville pump. (Courtesy Denton County Museums, *Denton Record Chronicle* Collection.)

BACK IN A FEW. Trucks, cars, and boat trailers are devoid of occupants as everyone is having fun on the lake in this early-1970s photograph. (Courtesy Dallas Public Library.)

WIND IN THE SAILS. Visitors to Lake Lewisville can enjoy a variety of water sports, like fishing, boating, and wave running. One of the most popular pastimes is sailing, as these boats moored to docks at the lake can attest. (Courtesy Denton County Museums, Denton Record Chronicle Collection.)

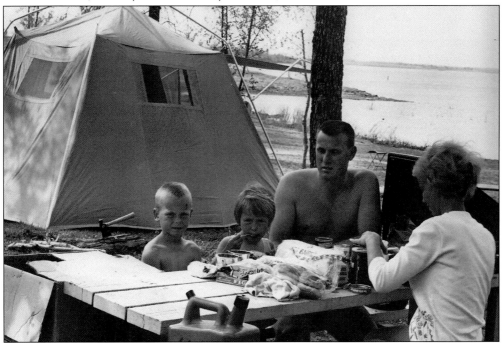

FAMILY PICNIC. Lake Lewisville attracts boaters, swimmers, fishers, nature lovers, and families for relaxation and togetherness. Lake Lewisville Park, operated by the City of Lewisville, offers camping facilities, boat docks, bike trails, and swim beaches and also hosts special events, such as an annual fishing tournament. The park also contains baseball diamonds and soccer fields. (Courtesy Denton County Museums, *Denton Record Chronicle* Collection.)

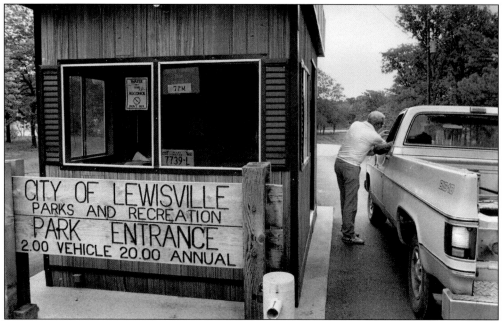

LAKE PARK. The City of Lewisville leases land from the Corps of Engineers in order to offer residents and visitors the opportunity to enjoy the lake. The city formed Lake Lewisville Park, which has become a prime destination for many North Texans. Every year, the city hosts a bass fishing contest that attracts hundreds of anglers and thousands of spectators. (Courtesy Denton County Museums, *Denton Record Chronicle* Collection.)

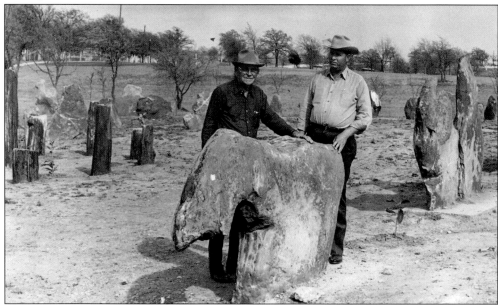

LAKE PAVILION. Lake Park features the Connor Pavilion, which can be rented for weddings and parties. Surrounding the pavilion are several sandstone slabs taken from the pavilion's site that were then planted upright. Lewisville mayor F.C. Connor (left), the pavilion's namesake, and Stan Lovette, who served as the head of the Corps of Engineers, posed next to the behemoths. (Courtesy Denton County Museums, *Denton Record Chronicle* Collection.)

Five

FARMERS NO MORE
MODERN LEWISVILLE

Lewisville experienced dramatic growth in the latter half of the 20th century. The city continued to expand culturally, economically, and demographically. Its reputation as a friendly, progressive community garnered nationwide attention, especially when the city attracted the Texas International Pop Festival on Labor Day weekend 1969, just a few weeks after the famed Woodstock festival. Contrary to the concert held in New York, the Lewisville event took place in good (albeit hot) weather, with friendly dealings all around. Residents still recall the days the "hippies" descended onto Lewisville.

Several major projects reshaped the city's economic landscape. The opening of the DFW International Airport in 1974 brought an influx of new residents to Lewisville. Several corporations, such as Xerox and Texas Instruments, set up shop in the city during the 1980s. Vista Ridge Mall solidified Lewisville's new business district on the south end of town. In 2008, the National Archives deemed Lewisville a good place to house the papers of Pres. George W. Bush until the presidential library in Dallas can be built.

The history of Lewisville is all about growth—and the city's expansion shows no sign of abating. Large immigrant populations from all over the world have given the city a new vibrancy. Rail and bus service connects the city to other communities. The downtown area has become Lewisville's Old Town, where one can get a haircut, attend a play, eat at restaurants, shop for farm produce, and buy jewelry from longtime merchants. Oh, and the feed mill still sells bags of animal feed, horse harnesses, and gardening supplies—practically anything a farmer or gardener would need.

Lewisville, after all, is still a farm town at heart.

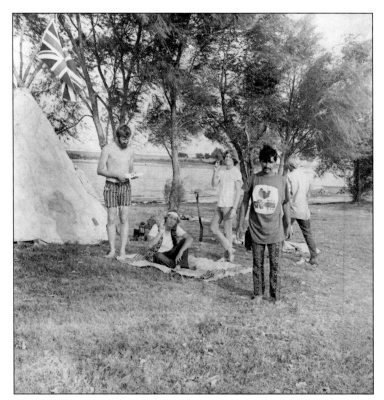

HIPPIE DAZE. During the hot, humid Labor Day weekend 1969, the Texas International Pop Festival welcomed tens of thousands of music fans to the Dallas Motor Speedway, located on Hebron Parkway in Lewisville. Lewisville residents were either appalled by or welcoming to the young music lovers, many of whom camped out at Lake Lewisville and skinny-dipped their way to coolness. (Courtesy Denton County Museums, *Denton Record Chronicle* Collection.)

LOVE AND SAFETY. The Hog Farmers from Taos, New Mexico, who also attended Woodstock, offered mellow guidance to the festivalgoers. While local residents were wary of the hippies, Lewisville police chief Ralph Adams maintained that "it [was] not the festival fans who [were] causing trouble, but the 'straight' people coming to look at the oddballs and the nude swimmers." (Courtesy Dallas Public Library.)

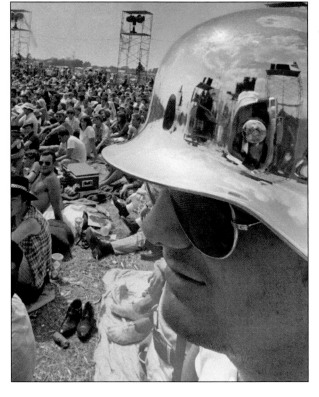

JAMMIN' JAM. Traffic jams proved to be the biggest nuisance for locals and concertgoers alike. During the festival, one person died from heat stroke, one child was born on the festival grounds, and many local businesses displayed signs that read, "Welcome beautiful people." Grocery stores ran low on picnic supplies, the Lewisville Hotel allowed attendees to use its showers, and some residents employed binoculars to ogle at the skinny dippers. (Courtesy Dallas Public Library.)

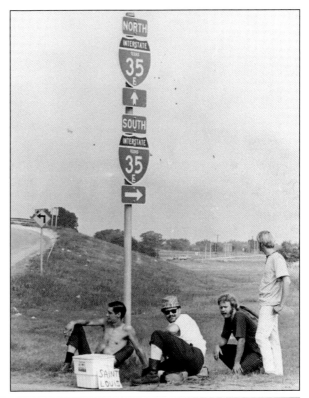

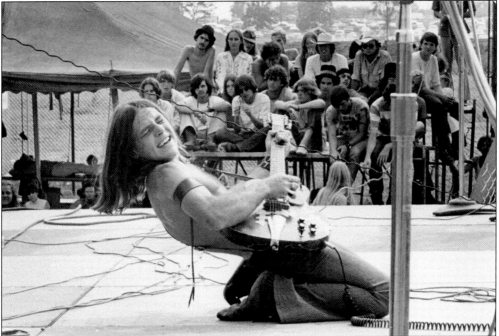

FAR OUT. Musical acts that celebrated the summer of love at the Texas International Pop Festival included Grand Funk Railroad (pictured), Janis Joplin, B.B. King, Led Zeppelin, Santana, Sly and the Family Stone, and many others. (Courtesy Dallas Public Library.)

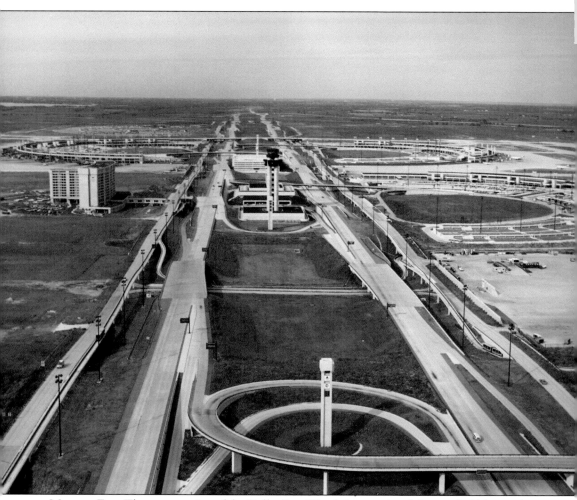

MODERN ERA. The construction of the Dallas Fort Worth International Airport held far-reaching consequences for Lewisville. State Highway 121, which ran just east of downtown Lewisville, served as the northern entrance for the airport, creating congestion but also many business opportunities. (Courtesy Dallas Public Library.)

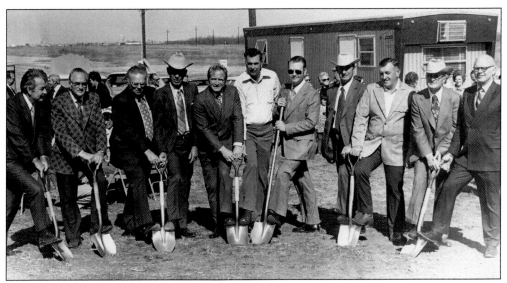

NEW DOWNTOWN. In the 1980s, Denton County built the Lee Walker Government Center in Lewisville to accommodate residents who did not want to drive into Denton to pay their taxes, obtain registration stickers, or visit the justice of the peace. This complex helped to anchor Lewisville's "second downtown" of municipal buildings, shopping centers, and the high school along West Main Street. (Courtesy Denton County Museums, *Denton Record Chronicle* Collection.)

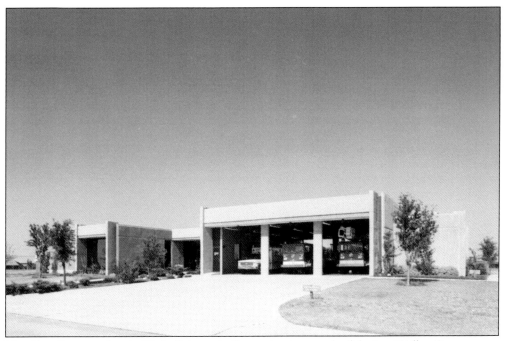

NEW FIRE STATION. Lewisville built its main fire station just south of the Lee Walker Government Center on Valley Parkway in the 1980s. After the September 11, 2001, attacks on New York City, Lewisville firefighters volunteered and held fundraisers to help their fellow firemen. Today, Lewisville firefighters host fire safety demonstrations at area schools with the help of the fun and informative "fire safety house." (Courtesy Dallas Public Library.)

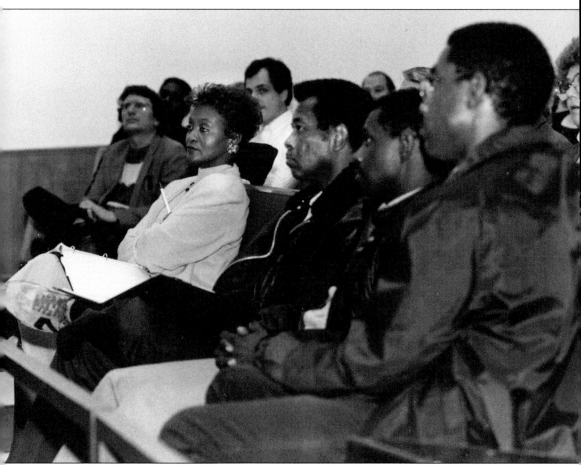

NEW EFFORTS. The Lewisville chapter of the National Association for the Advancement of Colored People (NAACP) organized in 1990. In this photograph by Mike Irvin for the *Lewisville News*, Lewisville mayor Bobbie Mitchell (foreground, left) listens to discussions on the clean up of Sycamore Park in southeastern Lewisville. Bobbie Mitchell was the first African American mayor of Lewisville and the third woman elected (Ann Pomykal and B.C. Groves blazed the trail before her). She now represents Lewisville as a Denton County commissioner. (Courtesy Denton County Museums, *Denton Record Chronicle* Collection.)

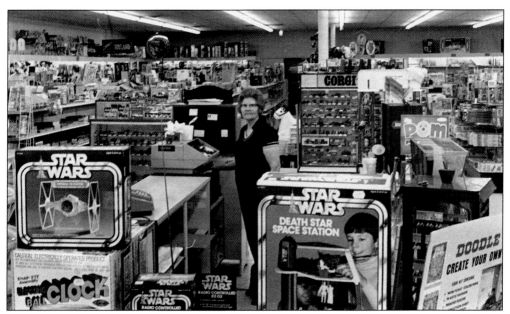

FUN STORE. Toy Mart opened in 1979 at the Old Orchard Shopping Village on West Main Street. The brand-new Star Wars toys—George Lucas's movie debuted in 1977—are now considered collectibles! (Courtesy Denton County Museums, *Denton Record Chronicle* Collection.)

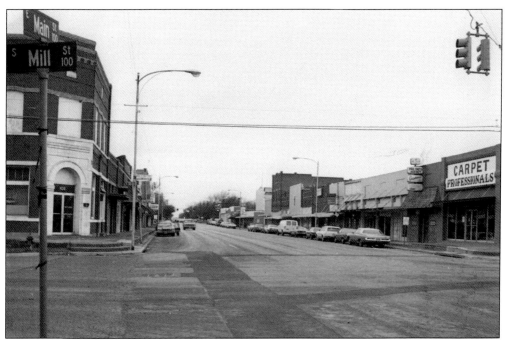

OLD DOWNTOWN. Mill and Main Streets do not look as busy as they used to in this photograph from the 1980s. Many buildings stand unused, including the old First State Bank. However, the Kirby Vacuum Cleaner Store, Beasley's Jewelry, the Paul Smith Insurance Agency, Carpet Professionals, and White's Store are doing well. (Courtesy James Polser.)

OLD TOWN PRESERVATION. When most retailers left downtown to set up shop in newer strip centers and city offices moved to modern locations in Lewisville's "second downtown," Old Town became neglected. Melissa Atkinson, photographed by Jeff Cohen for the *Lewisville News*, helped to revitalize a flagging Old Town in the 1990s through her involvement with the Old Town Business Association. The Old Town Business Association presented monthly awards to small businesses, helped to develop enticements to bring customers to Main Street, and fostered cooperation with the Old Town Preservation Society. (Courtesy Denton County Museums, *Denton Record Chronicle* Collection.)

HERITAGE CELEBRATION. Every September, Lewisville pays tribute to its rural roots by hosting Western Days in Old Town. The festival features country-western music, arts and crafts, all kinds of foods, and a rodeo. An exciting event is the cattle drive, where cowboys and cowgirls wrangle longhorns through downtown Lewisville. (Courtesy Denton County Museums, *Denton Record Chronicle* Collection.)

CHARITY. Christian Community Action (CCA) began in 1973 as a small charity organized by the St. Philip Catholic Church of Lewisville and is now one of the largest charities in North Texas, with its headquarters in Old Town Lewisville. CCA raises money through donations and secondhand retail stores, like Bargain Depot, where most Lewisville residents have found a treasure or two. (Courtesy Denton County Museums, *Denton Record Chronicle* Collection.)

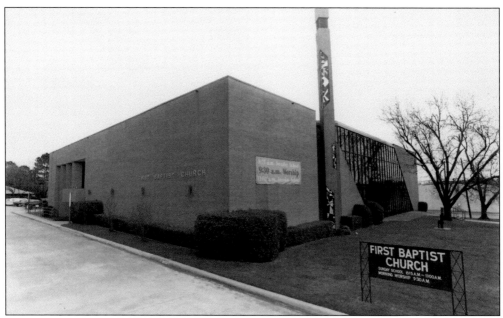

LAST ON CHURCH. The First Baptist Church was the last of the original Lewisville churches that graced Church Street. The congregation moved to a much larger church west of downtown. Ironically, the location of the new church is just a few hundred yards away from the original Baptist church on Holford's Prairie. (Courtesy Denton County Museums, *Denton Record Chronicle* Collection.)

AGING MEMBERS. Longtime Lewisville churches saw their membership grow older as years passed by. In this photograph by Matt Brunworth and Mike Irvin for the *Lewisville News*, Gladys Shelby, the oldest member of the Lane Chapel CME Church in Old Town, celebrated this milestone inside the sanctuary. (Courtesy Denton County Museums, *Denton Record Chronicle* Collection.)

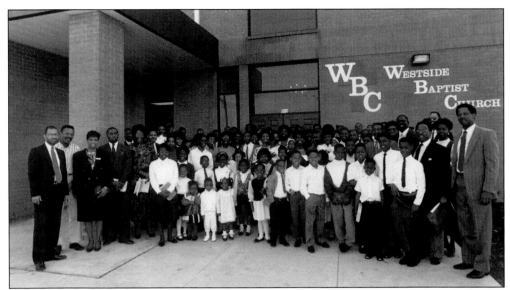

MODERN CHURCH. Founded by members of the Lakeland Baptist Church in 1983, Westside Baptist Church has grown into a huge complex with over a thousand worshippers visiting every Sunday. The church occupies the southern portions of Bellaire Boulevard and Edmonds Lane. (Courtesy Denton County Museums, *Denton Record Chronicle* Collection.)

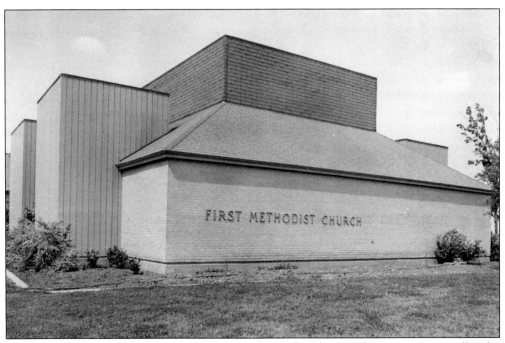

NEW METHODISTS. Once occupying a grand church building in downtown Lewisville, the United Methodist congregation moved to a new abode at the corner of West Main Street and North Summit Avenue. The church simply followed its flock, as most Lewisville residents were moving west of downtown by the late 1960s. (Courtesy Denton County Museums, *Denton Record Chronicle* Collection.)

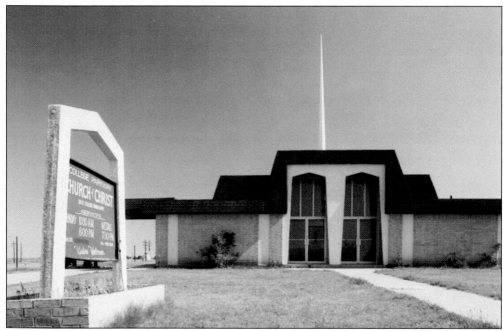

NEW CHURCHES. New churches, like the College Parkway Church of Christ, came into being as new suburban housing developed west of Interstate 35. (Courtesy Dallas Public Library.)

WHAT'S NEW IS OLD. Holford's Prairie, the original location of Lewisville, became part of the town once again when new housing developments, like the Valley Addition, built up around the Old Hall Cemetery. (Courtesy Dallas Public Library.)

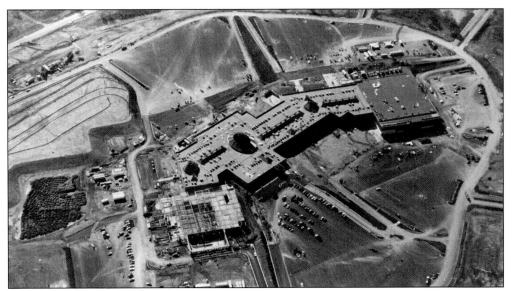

TEEN'S DREAM. In 1987, the Vista Ridge Mall opened southwest of downtown Lewisville, and it is still a major retail hub today, featuring stores like Sears, Macy's, Dillards, and J.C. Penney. The mall anchors a large real estate expansion that includes strip malls, housing, recreational areas, businesses parks, and an amphitheater. (Courtesy Denton County Museums, *Denton Record Chronicle* Collection.)

YUMMY LEWISVILLE. Grandy's, a fast-food restaurant that serves Southern, home-style meals, opened its first outlet along Interstate 35 in Lewisville. Its Lewisville-based corporate headquarters are located on the appropriately named "Grandy's Lane." (Courtesy Denton County Museums, *Denton Record Chronicle* Collection.)

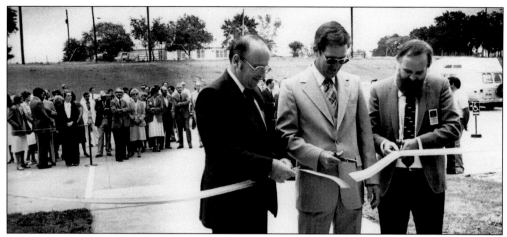

CORPORATE LEWISVILLE. The Xerox Corporation opened a 100,000-square-foot distribution center near Railroad Street in 1981. Attending the ribbon-cutting ceremony are, from left to right, Vice Pres. Thomas Skelly, Lewisville mayor Tory White, and union representative Charlie Hughes. (Courtesy Denton County Museums, *Denton Record Chronicle* Collection.)

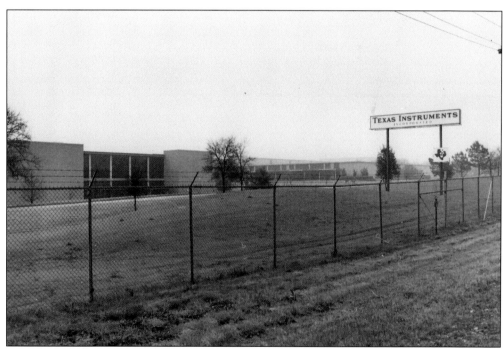

TECHNOLOGICAL LEWISVILLE. Dallas-based Texas Instruments opened its Lewisville campus in 1988. Here, engineers and technicians configured and manufactured "defense suppression persistent weapons," guidance systems, and anti-radar seekers. Lewisville received a big boost to its economy with the influx of highly skilled workers moving to the area to live and work. (Courtesy Denton County Museums, *Denton Record Chronicle* Collection.)

NEW LEWISVILLE. Lewisville's city government operations have relocated four times since the city's incorporation in 1925. A small brick structure, built in 1927, housed the city's first offices on Poydras Street. In 1956, the city erected a multipurpose government building, which included a post office, at Charles and Church Streets. In 1989, the city moved to brand-new digs across Interstate 35 on West Main Street. Finally, the city relocated back to its original roots—Old Town—when it dedicated this splendid new city hall in 2003. Lewisville has come a long way from its humble beginnings as a farm town in cotton country. Still, even with all the pains that come with expansion, the city has managed to stay true to its origins. Go Farmers! (Author's.)

Discover Thousands of Local History Books
Featuring Millions of Vintage Images

Arcadia Publishing, the leading local history publisher in the United States, is committed to making history accessible and meaningful through publishing books that celebrate and preserve the heritage of America's people and places.

Find more books like this at
www.arcadiapublishing.com

Search for your hometown history, your old stomping grounds, and even your favorite sports team.

Consistent with our mission to preserve history on a local level, this book was printed in South Carolina on American-made paper and manufactured entirely in the United States. Products carrying the accredited Forest Stewardship Council (FSC) label are printed on 100 percent FSC-certified paper.